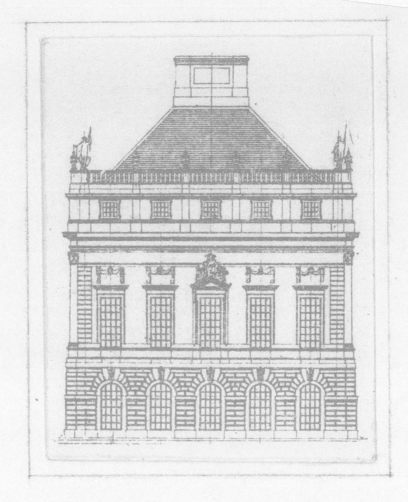

THE
QUEEN'S
DOLLS'
HOUSE

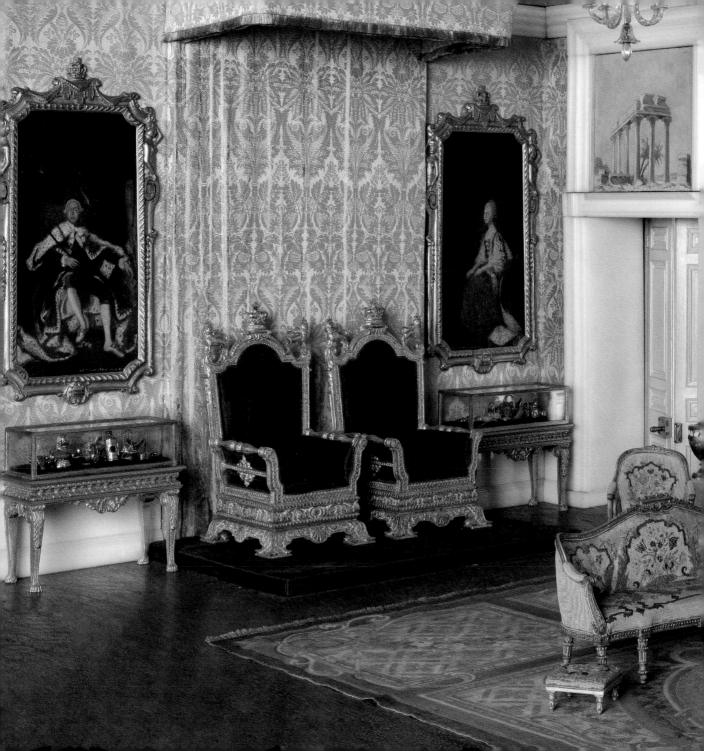

THE QUEEN'S DOLLS' HOUSE

Lucinda Lambton

ROYAL COLLECTION TRUST

CONTENTS

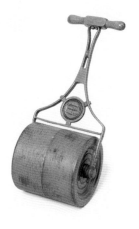

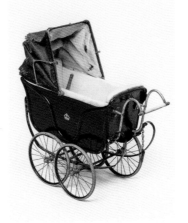

INTRODUCTION

It is as extraordinary as it is wonderful that, after the First World War, the great and the good of the largest empire in the world chose to mark the moment by concentrating whatever was finest, most ingenious and most beautiful in the country within the narrow confines of – a dolls' house, albeit one which to this day is considered among the finest architectural models in the world.

How and why did this happen? How was it possible that this little house within-a-house should ensnare the devotion of over a thousand of the great men and women of the day, as well as three years' passionate attention by the country's greatest architect?

It was Princess Marie Louise (1872–1956), Queen Victoria's granddaughter, who first thought 'on the impulse of the moment' of asking her friend the renowned architect Edwin Lutyens (1869–1944) to design a dolls' house for Queen Mary, the consort of Marie Louise's first cousin, King George V.

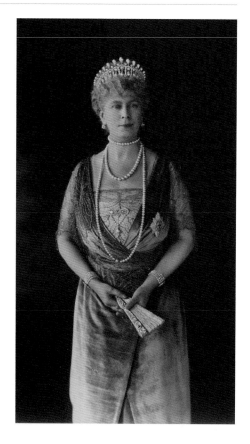

W. & D. Downey,
*Queen Mary of Great
Britain and Ireland*, 1929.

The view through the Queen's Bathroom. In this period Lutyens was designing in his 'Wrenaissance' style; his refinement of classicism was inspired by the spirit of Inigo Jones and by Christopher Wren, whose influences can be seen whispering through the façades of the little building.

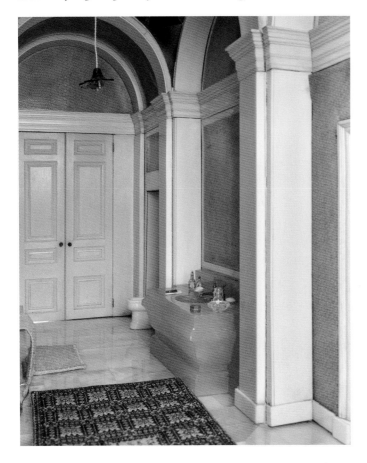

Queen Mary was an obsessive collector of *objets d'art*, most particularly of 'tiny craft', and most passionately of those with a family connection, which she amassed with an acutely knowledgeable eye. There could be no better gift for her than a dolls' house filled with diminutive treasures. What more suitable tribute could be created for the Queen as a mark of respect for her steadfast presence throughout the War? With its English eccentricity, this miniature yet monumental scheme was spot-on to capture the world's imagination.

As a last hollering HUZZAH for the vanishing Edwardian age (with loud echoes from the Victorians) the Queen's Dolls' House, which now belongs to Queen Mary's great-grandson, King Charles III, is a creation unlike any other. An exquisite little building, designed with serious intent by the great architect of the day and filled to its rafters with the work, in miniature, of the finest artists and artisans, craftspeople and manufacturers of early twentieth-century Britain. Such is its sympathy, accuracy and attention to detail that, within seconds of staring into its tiny chambers, all sense of scale is swept away. Roam your eyes through the rooms great and small (the views through the doors are particularly beguiling) and a spell is cast, magically enabling you to feel as if you are strolling through a sensational set-piece, untouched by human hand since the day it was finished in 1924. I rest my case: this is something of a miracle.

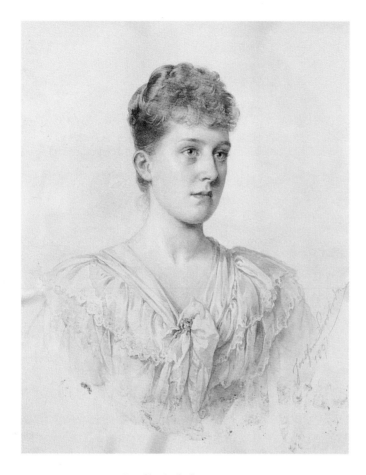

Josephine Swoboda,
Princess Marie Louise of Schleswig-Holstein, 1891

Princess Marie Louise was the daughter of Queen Victoria's
fifth child, Princess Helena, and thereby first cousin to
King George V. A childhood friend of Queen Mary, after her
unhappy marriage to Prince Aribert of Anhalt was annulled
she moved back into Cumberland Lodge in Windsor Great
Park (the house that had been her father's home, as Ranger
of the Park). It was her popularity in artistic circles that
contributed greatly to the success of the Dolls' House. In a
letter to his wife, Lutyens described the Princess as being
'full of bounce and fun', and gave her the nickname 'Mary
Louse' (while she in turn called him 'Sned').

Sir William Rothenstein, *Sir Edwin Lutyens*

The suitability of Sir Edwin Lutyens – he
was knighted in 1918 – as the architect of
this 'Palace of Enchantment' was twin-
speared: not only had he created a multitude
of Arts and Crafts houses so indigenously
English that they seem to grow out of the
very body of the Surrey landscape and
beyond, but he was also responsible for
many First World War memorials, most
notably the Cenotaph in Whitehall.

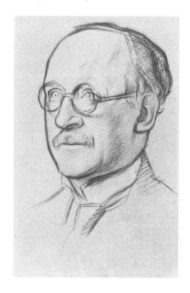

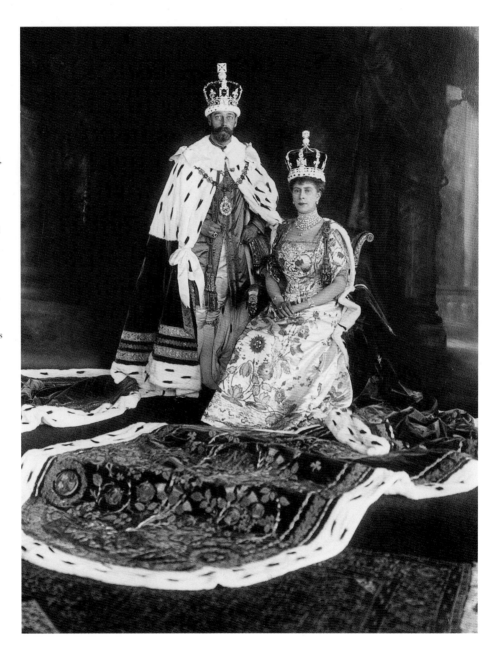

King George V and Queen Mary in Coronation Robes, 22 June 1911

Queen Mary's passion for collecting was all-consuming. Having inherited the love of it from her parents, Francis, Prince of Teck and Princess Mary Adelaide, a granddaughter of George III, she was, from the earliest days of her marriage, relentlessly determined to retrieve and reassemble whatever historic royal relics had been scattered throughout the royal households, or had otherwise found their way to the salerooms. Thanks to her, many important pieces were restored and collections brought together again. Happily hand-in-hand with this considerable service went her craving to collect all things small for her own pleasure, which she did with an endless and zestful glee. So it is that every surface in the state rooms of what she often referred to as 'My Dolls' House' displays tiny treasures. In, as she called it, 'My Bedroom', a Fabergé mouse (given by the Grand Duchess Xenia of Russia) sits on her writing table, alongside a miniature of King George V.

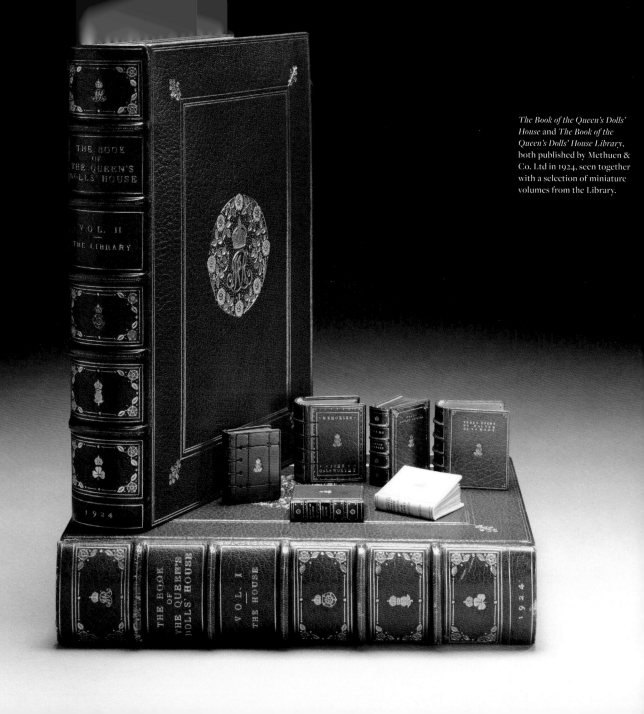

The Book of the Queen's Dolls' House and *The Book of the Queen's Dolls' House Library*, both published by Methuen & Co. Ltd in 1924, seen together with a selection of miniature volumes from the Library.

E.V. (Edward Verrell) Lucas was a highly prolific and popular writer, producing poetry, novels, biography and essays on everything from travel to cricket. A close friend of both Lutyens and Princess Marie Louise, he was instrumental in the assemblage of works for the miniature Library.

The architectural writer Lawrence Weaver was knighted for his directorship of the United Kingdom stands at the British Empire Exhibition in Wembley, where the Dolls' House was first shown. As architectural editor of *Country Life* he was the ideal individual to involve in the authentic furnishing of the house's interior.

A.C. (Arthur Christopher) Benson, academic and author, is best known today for his words to 'Land of Hope and Glory'. Son of E.W. Benson, Archbishop of Canterbury, he was Master of Magdalene College, Cambridge, at the time of the Dolls' House's production.

In 1924 a limited edition of two official volumes was published: *The Book of the Queen's Dolls' House* and *The Book of the Queen's Doll's House Library*. The first was edited by the essayist and poet A.C. Benson and the architectural writer Sir Lawrence Weaver, the second by popular author E.V. Lucas. Involved at every stage of the Dolls' House's creation, these three marshalled the forces of its most important contemporary chroniclers to write on every aspect of the little building. At the same time the smaller and mainly condensed *Everybody's Book of the Queen's Dolls' House* was published. With the very taste of those times on the tongues of all the contributors, as it were, you will find that they have been quoted in this volume whenever possible.

ARCHITECTURE & ORNAMENT

In 1921, when Lutyens took on the Dolls' House, he had been working on the building of New Delhi for nine years; a grand scheme that, with the growth of India's independence movement, was becoming ever more provocatively anachronistic. Changes and cut-backs, for economic reasons, were forever being made to his vast Viceroy's House, and when the chance came to build a full-whack wonder for Queen Mary – albeit in miniature – Lutyens embraced it with gusto. Also hugely important for the architect was that he could design the Dolls' House in the classical style, an approach no longer wholly possible in New Delhi, thanks to concessions to Indian styles. It gave him particular pleasure to be simultaneously applying himself to eighty square miles of Imperial buildings as well as to a Dolls' House measuring only five feet high. Unbeknown to him, greater glory lay ahead,

OPPOSITE: The exterior, clad in wood, carved to look like rusticated Portland stone (one of the few architectural pretences) has crisp Corinthian columns as well as floral swags and friezes in deep relief. There are two coats of arms: to the north with the lion and unicorn for King George V, and to the south, above the Queen's Bedroom window, Queen Mary's arms with the British lion on the left and the stag of Württemberg on the right, proclaiming her German ancestry.

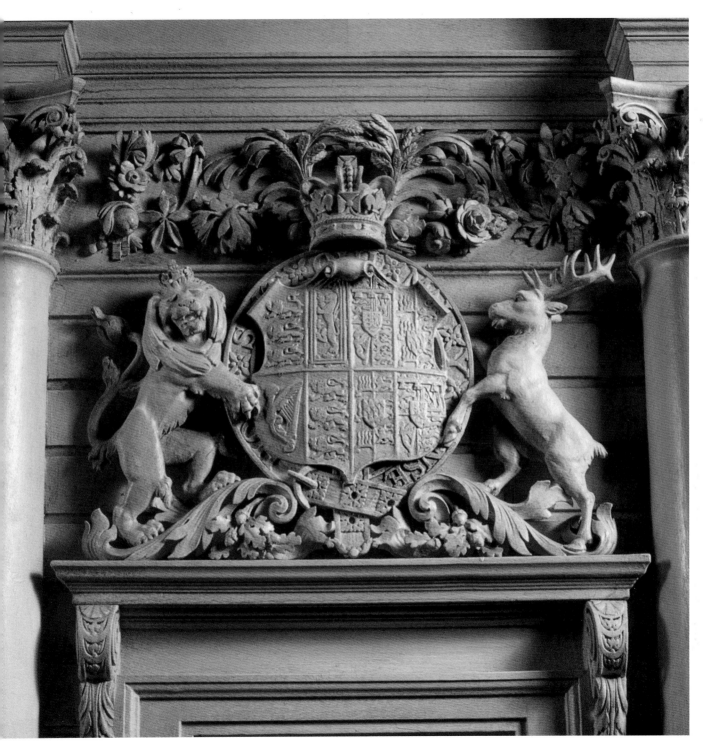

with the strange scenario of the Queen's Dolls' House becoming a symbol of Britain's post-war renewal.

These were the years of post-war convalescence, when the largely unemployed country (for architects, artists and artisans it was particularly bleak) needed help to stand on its feet once again, in a country 'fit for heroes to live in'. In 1922 the British Empire Exhibition of Arts and Manufacturing, conceived to boost spirits and to stimulate trade, was given the go-ahead; what could be a more cheering centrepiece than this tiny masterpiece model of an English house, displaying the very best that the United Kingdom could offer? So it was that this remarkable creation, which could well have become a mere plaything for Queen Mary's pleasure, a fantastical toy subsumed into the wealth of the Royal Collection, was to become instead a work of art – in fact hundreds of works of art – and a beacon of national importance. Indeed, within days of its inception it was seen as a flagship of endeavour to ease the nation's woes.

'That most frolicsome of men and architects, Sir Edwin Lutyens ... at once took fire', wrote E.V. Lucas. 'Everyone to whom he communicated the scheme took fire too.' Lutyens regularly began to hold what he called

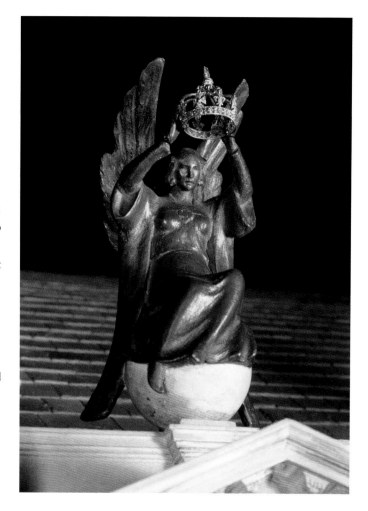

On the balustrade around the roof stand the four patron saints of the British Isles, as well as four figures emblematic of the Christian names of the Queen – Victoria, Mary, Augusta and Louise. Taking centre stage is an angel bearing the Queen's crown (illustrated here). All were sculpted by Sir George Frampton. And soaring overall, two great chimney stacks gracefully cope with the working fireplaces that feature in every room.

Sir George Frampton was the sculptor responsible for the House's exterior ornamentation, as well as for the two lions that guard the entrance to the British Museum in Montague Place and the statue of Peter Pan that stands in Kensington Gardens.

The roof is made up of real slates.

'Dollyluyah Dinners', and these were eventually to inspire more than 1,200 individuals to become involved in the Dolls' House in one way or another. It was a formidable force, the whole gamut of early 1920s British life (with dashing additions from both India and America): 250 artisans and manufacturers, 60 artist–decorators and 700 artists, 200 writers and 500 donors, many of them still household names today. Many, too, that have long since been forgotten – vanished footprints in the sand, brought into exquisitely sharp focus when seen again in this little building.

Lutyens treated the design of the Dolls' House as an ingenious architectural exercise, whereby (within the strictest rules of symmetry) he created lofty royal chambers along with mezzanine levels, and ensured that every room had a window, with either casement or real sliding sashes, all of them adding to the perfection of the whole. 'It is because the Queen's Dolls' House ... shows a just balance between tradition and invention', wrote Sir Lawrence Weaver, 'that it must be regarded not as an architectural whim or as an elaborate nursery jest, but as a serious synthesis of the building arts of our generation.'

Built on the imperial scale of 1 inch to 1 foot; 5 feet (1.52 m) high, 102 inches (2.59 m) wide, and 58.5 inches (1.49 m) deep, it is almost small enough to give the viewer an agreeable sense of being able to embrace it in one satisfying go, and smothering it with admiring kisses.

From the outside, what initially appears to be a podium supporting and uplifting the house is in actual fact the basement quarters, to be shown off by letting down rusticated stone flaps and revealing, to the north, the water tank and machinery for the lifts; to the south, the

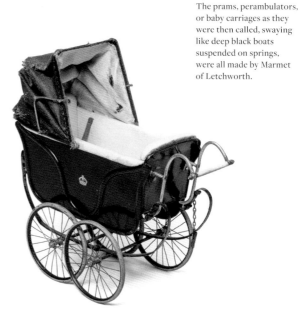

The prams, perambulators, or baby carriages as they were then called, swaying like deep black boats suspended on springs, were all made by Marmet of Letchworth.

A stone balustrade bulges forth, with stone piers and wrought-iron gates, bearing lead cherubs holding the royal arms created by the seventeenth-century sculptor Grinling Gibbons. A cipher of two *G*s intertwining to form the letter *M*, found at the top of the gates, also appears embroidered over the bedhead in the Queen's Bedroom (pp.64–5).

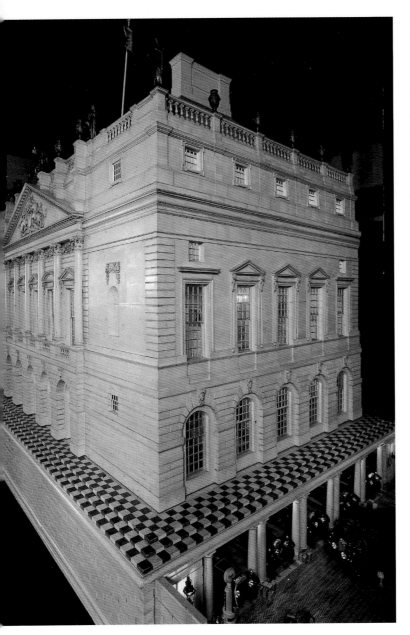

Wine Cellar and food stores. Most ingenious of all are the revelations to be found in the great drawers at either end of the building. With the flaps pulled down, ABRACADABRA! To the west you haul forth a fully fledged five-bay garage, housing a fleet of royal limousines; while to the east, a garden by Gertrude Jekyll (1843–1932) – empress of garden design in her day – literally leaps into life. With an invisible hinge stretching the width of the Garden, all can be folded flat and pushed out of sight. Pull it out again, fold it over, and like a lively cheer for this little horticultural oasis, its six cypress trees – made from real twigs on iron trunks – all stand up straight once again.

So as to be able to exhibit the Dolls' House exterior and interior at once, Lutyens devised the 'highly ingenious electrical contrivance' to lift the outer shell on high, thereby allowing you, in one glorious go, to see every aspect of the little building, both outside and in. What an interior it is too …

There can surely be few more splendid last salvos from Edwardian England than the decoration applied inside the Dolls' House, with its woodwork, plasterwork and damask-hung walls; its superbly imaginative ceiling paintings, many by master craftspeople of the day; as well as the murals by such giants

as William Nicholson and Edmund Dulac. There is a wealth of rich-hued marble too – a small hint of Britain's imperial reach at this time. The Indian government donated sufficient quantities to furnish many of the walls, floors, door-cases, dados and ceilings, and most particularly fashioned into fireplaces, which then decreed the decorative colour scheme of the rooms.

The shell of the little building was created in 1921 by Lutyens in his Apple Tree Yard office in London, a handy stone's throw from the Royal Academy. Distinguished Royal Academicians would sally forth to paint the tiny walls and ceilings, often exchanging notes with Queen Mary, who would come to watch their progress. Although Lutyens had the final say, credit must be given to the Queen for delighting for once (her tastes were usually safely conservative) in such avant-garde schemes as the mural for her Bedroom ceiling by Glyn Philpot (1884–1937), with its panel of 'perished mirror work' surrounded by red-winged cherubs amid dark, storm-ridden clouds.

The painted ceilings are the oddest and rarest of all the decorative elements in the house. In the King's Bedroom, the notes of the National

OPPOSITE: Cut-away view of the front elevation of the Dolls' House, from the wine cellars in the basement to the Nursery in the attic.

BELOW: Detail of stormclouds from the ceiling of the Queen's Bedroom by Glyn Philpot.

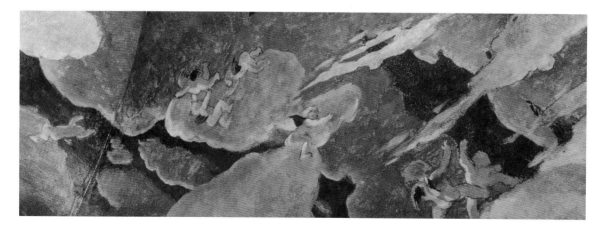

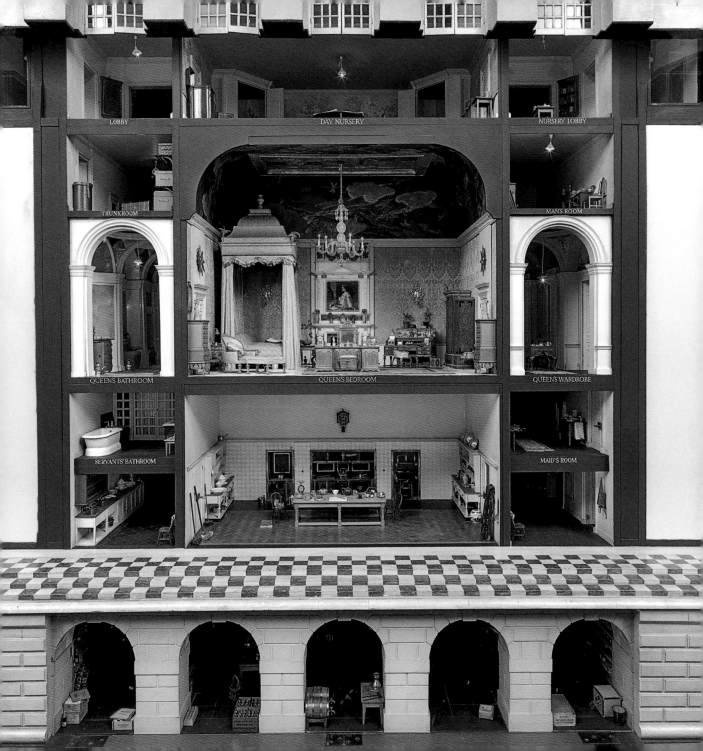

LOBBY DAY NURSERY NURSERY LOBBY

TRUNK ROOM MAN'S ROOM

QUEEN'S BATHROOM QUEEN'S BEDROOM QUEEN'S WARDROBE

SERVANTS' BATHROOM MAID'S ROOM

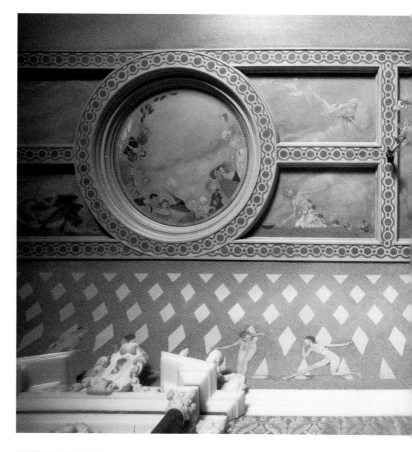

The artist responsible for the
decoration of the Saloon ceiling,
Charles Sims, painted ever more
idiosyncratically following his
experience as an official war artist
and the death of his son in the First
World War, and was tragically to
drown himself in the River Tweed.

Anthem are painted as entwined through
canes on a garden gazebo. Naked figures,
unmistakably of the 1920s, prance around the
cove of the Saloon ceiling, while in panels on
high *The Children of Rumour with her Hundred
Tongues* veers towards the modernistic. It is
a rich roll-call: the Library's sombre beauty
of Italian walnut columns and panelling has a
painted ceiling by William Walcot (1874–1943),
a celebrated architectural draughtsman who
left a legacy of buildings in Moscow, while in
the Dining Room, ceiling panels and *trompe
l'oeil* overdoors were painted by Gerald Moira
(1867–1959), a key Pre-Raphaelite figure
largely forgotten today but whose work
can still be admired in the Old Bailey court
building in London.

All these diverse elements of 1920s England
are woven into the very fibre of the house. The
culture of the country is embodied in these
walls: in the Queen's Bathroom three shallow
domes, set in pendentives of smoked snail-shell
and painted with mermaids, whales and fish in

Pietra dure table top
of lapis lazuli and
white marble inlaid
with parrots and floral
scrolls. This giltwood
table made by Lord
Turner & Co. and
H. T. Jenkins & Sons
adorns the Saloon.

The King's Bedroom ceiling was the work of the American-born George Plank, a nationalised Englishman from 1945 who lived the last years of his life in a house designed for him by Lutyens. The orange flowers mark the notes for the tune of the National Anthem.

The vaulted ceilings in the King's Bathroom were painted by Captain Laurence Irving (1897–1988), grandson of the actor Sir Henry Irving.

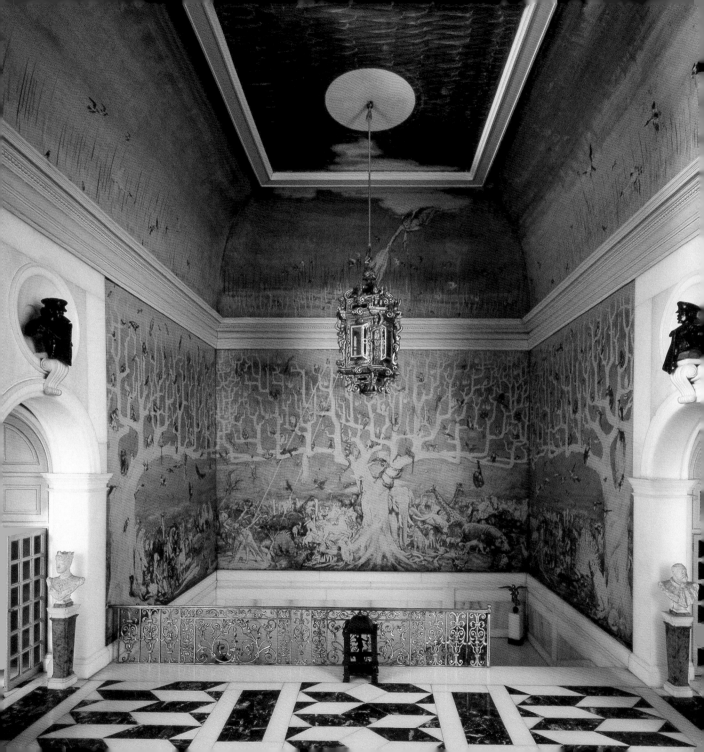

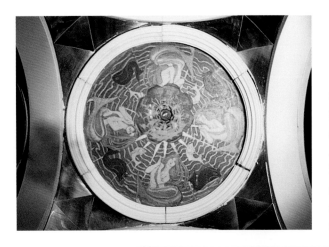

rippling waves, are all by Maurice Greiffenhagen (1862–1931), a friend of H. Rider Haggard and the illustrator of Haggard's popular adventure novel *King Solomon's Mines* (1885). In the Queen's Wardrobe, Robert Anning Bell (1863–1933), a hugely influential artist, illustrator, sculptor and mosaicist, painted circular ceiling panels of the four seasons and the five senses – three of them, strange to see, wearing 1920s' hats.

ABOVE: The Queen's Bathroom ceiling by Maurice Greiffenhagen.

RIGHT: The Queen's Wardrobe ceiling by Robert Anning Bell with its mural of the senses.

OPPOSITE: William Nicholson, Lutyens's great friend, was originally asked to paint the coved ceiling in the Hall. He went the whole hog with a mural over three floors, of three giant bleached trees soaring over Adam and Eve as they are expelled from the Garden of Eden by a winged thunderbolt. They are being watched, as Nicholson put it, 'by their pets' – which would appear to be every creature on God's earth.

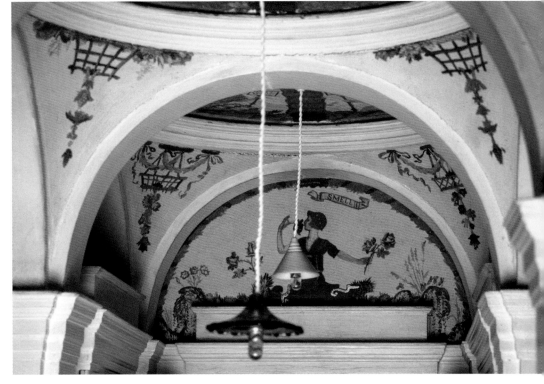

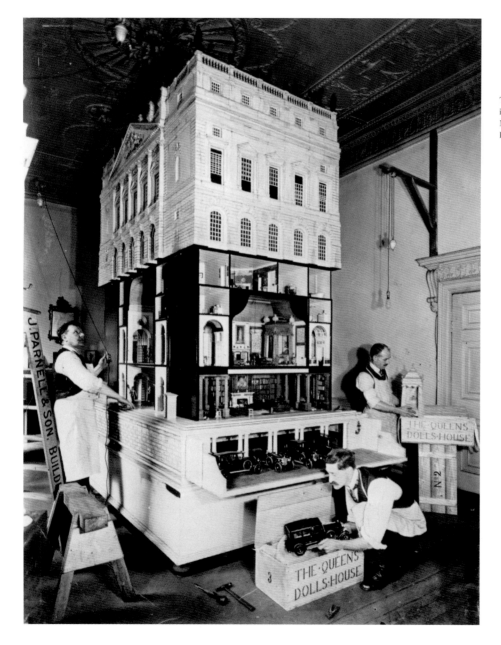

The Dolls' House
in Lutyens's home,
Mansfield Street,
London.

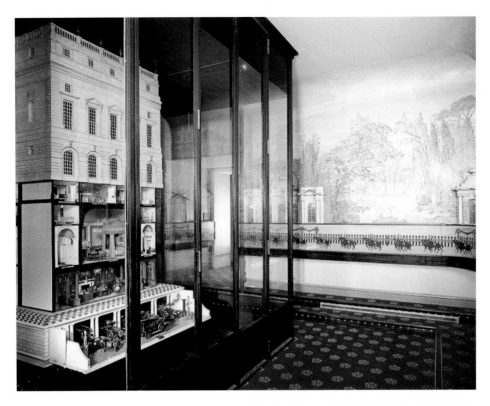

LEFT: The House in its current location in Windsor Castle.

BELOW: The Dolls' House being admired at the British Empire Exhibition at Wembley by the royal party and Lutyens.

When the shell of the house was finished (complete with electric wiring and plumbing) it was moved, with the wall of his office being torn down to get it out, to Lutyens's house in Mansfield Street. There it was to stand, taking up half his drawing room for nearly two inconvenient yet wildly exciting years. The elite of the nation's talent had been moved to contribute and they poured through the door: Sir Alfred Munnings (1878–1959) with his miniature painting of the King's charger, named 'Delhi', following the Delhi Durbar; Alfred

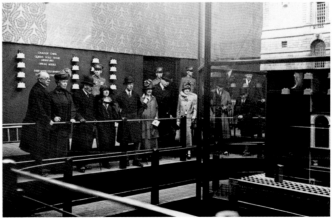

Dunhill (1872–1959) with his tiny cigarettes, cigars, pipes and tins of 'My Mixture' – tobacco custom-made for the King. Ursula Ridley, Lutyens's favourite daughter, told me, her eyes alight with delight, of Sir Arthur Conan Doyle (1859–1930) arriving with his diminutive, hand-written and leather-bound story *How Watson Learned the Trick*. Queen Mary, enjoying every development, came to Mansfield Street several times and, according to Lutyens's youngest daughter Mary, her father and the Queen would go for five-mile walks together, exchanging ideas. So great did their friendship become that when the Queen asked the meaning of the *MG* and *GM* embroidered on two tiny pillowcases, Lutyens had no hesitation in explaining saucily: 'May George?' and 'George May'.

In 1924, after three years' work, the Dolls' House was finished. 'The most perfect present that anyone could receive', wrote the Queen to all those involved in its creation. Having been presented to the press – all of them scrunched into the Mansfield Street drawing room – it was borne off to the British Empire Exhibition at Wembley to be shown off in triumph to the nation; although, as was reported in the press 'even dolls' houses ... are not immune from the dislocating effects of a general election', political rivalry for centre stage postponing

3.9 cm

ABOVE: Sir Arthur Conan Doyle, *How Watson Learned the Trick*, 1922.

RIGHT: The Queen's letter of thanks 'to all the very kind people who have helped to make the Dolls' House the most perfect present that anyone could receive'.

BELOW: Smoking items, including 'My Mixture', tobacco custom-made for the King.

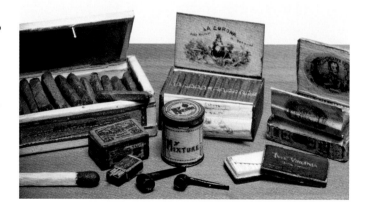

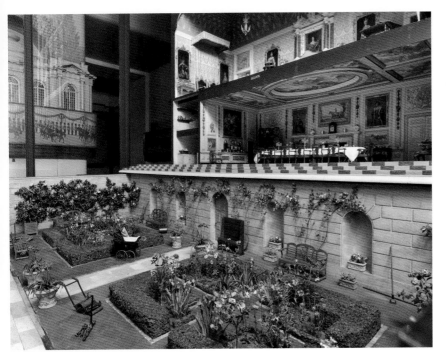

No detail was forgotten; in order that the lawn's edge could be cut clean by the mower, diminutive bricks have been laid for the outer wheels to roll on, thus keeping the blades in line with the edge of the grass (BELOW). This particular model of lawnmower was introduced in Birmingham in 1920 by Atco, a firm still producing mowers today (ABOVE).

the House's unveiling by a week. During its seven months at Wembley the Dolls' House was to be seen by 1,617,556 people. It was 'A Miracle in Miniature' according to *The Times*, 'a dangerous sight for half-believers in magic'. A year later, to raise money for the Queen's charitable fund, it was taken off again, in forty-five boxes weighing four and a half tons, to the Ideal Home Exhibition at Olympia in West Kensington. Finally, in July 1925, it was put on show in Windsor Castle, in a room specially designed by Lutyens. There it has remained ever since.

LEFT: Lutyens's now famed-the-world-over garden benches stand proud, while hydrangeas and rhododendrons are planted in his still-popular wooden tubs.

ABOVE: Gertrude Jekyll oversaw the creation of the miniature garden.

CHAPTER TWO

BELOW STAIRS

A further purpose in the minds of those who designed, constructed and furnished the Queen's Dolls' House was to present to Her Majesty a little model of a house of the twentieth century which should be fitted up with perfect fidelity, down to the smallest details so as to represent as closely and minutely as possible a genuine and complete example of a domestic interior with all the household arrangements characteristic of the daily life of the present time ... an interesting and lifelike memorial for future times of the sort of way in which people of our own days found it desirable and agreeable to live ...

A.C. Benson
The Book of the Queen's Dolls' House, 1924

OPPOSITE: The linen truly astounds, with an abundance of damask, cotton, flannel and wool, from the finest tablecloths to pudding cloths. There are 'royal' sheets, while the servants' pillowcases have buttons barely visible to the naked eye. Red and white glass cloths are stacked beside kitchen roller towels; doilies (round and square) keep company with embroidered napkins. All are neatly stored in the cupboards and tied with coloured ribbons to show where in the house they belong. Every last one is monogrammed with such delicacy that one is tempted to say it could only have been the work of fairies, although in fact it is known to have been done by a lone Irish–French seamstress who spent 1,500 hours on the job.

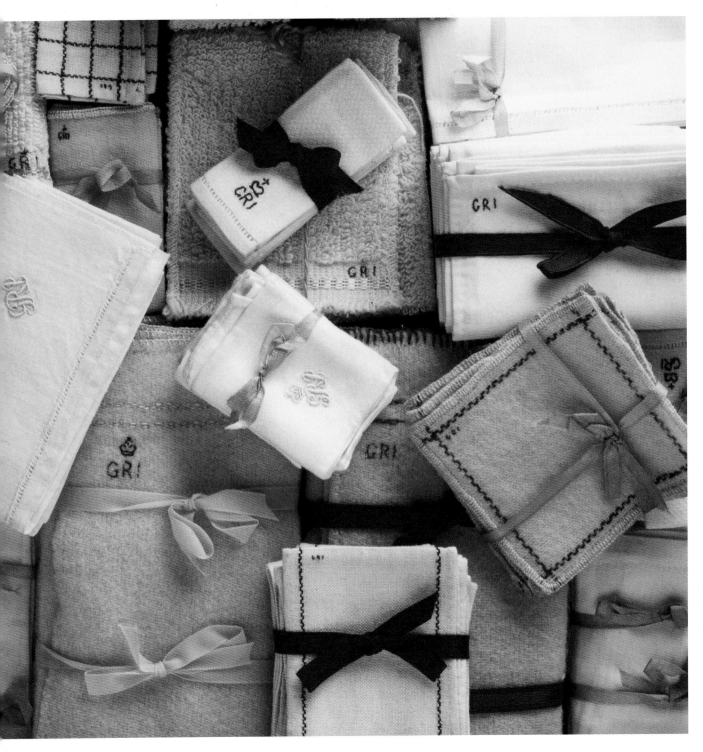

Suppose that a Saxon manor were to be discovered today with every domestic detail intact, or an Elizabethan mansion, or an eighteenth-century stately pile. Being able to see such aspects of daily life would be nothing short of miraculous. Yet that is precisely what can be relished with the Queen's Dolls' House. Here is a unique chance to see the workings of a grand early twentieth-century house, down to its last and most domestic detail.

The Queen's Dolls' House was already somewhat anachronistic when it was built in 1924. In spite of the post-war hard times, Lutyens and his team of creators and contributors still took it for granted that a great house would march forth into the future with an active and hierarchically ranked army of servants. Likewise, the seductive echoes can be heard of Edwardian opulence; echoes that still reverberate through its tiny rooms today. Nor are the servants' quarters forgotten. Here, too, Lutyens characteristically applied himself down to the most diminutive detail, so as to make the lives of their imaginary inhabitants as comfortable as possible (though the lack of a Servants' Hall for convivial get-togethers is regrettable). With the heartbeat of the house thumping away in the Kitchen, the quiet dignity of the wood-lined Linen Room, the

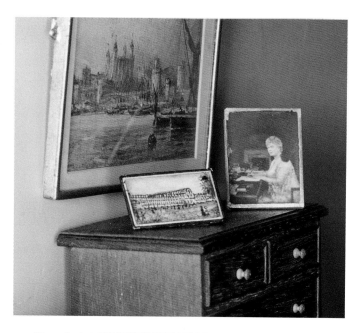

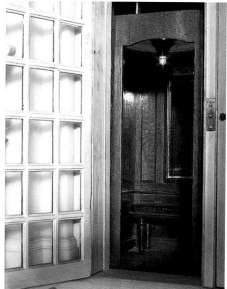

ABOVE: A photo of Queen Mary in one of the servants' rooms.

LEFT: The fully-functioning passenger lift, which is to be found to one side of the Halls.

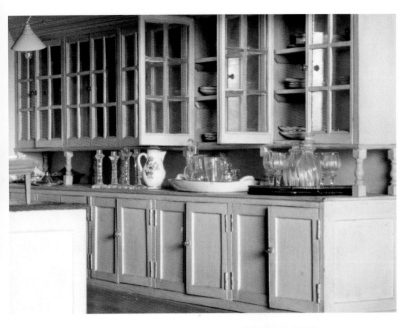

The Ewbank Carpet Sweeper sits in the Kitchen.

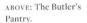

ABOVE: The Butler's Pantry.

RIGHT: American 'Bromo' lavatory paper, here pictured with the King's water closet.

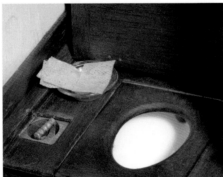

whirl of work in various domestic offices, the well-furnished and picture-hung 'Men's' and maids' bedrooms, and the startlingly opulent contents of the Garage, there were separate little kingdoms within this royal household.

And with such technological triumphs as five bathrooms (all with running water), two Waygood Otis electric lifts from the United States of America (one a 'passenger car' of polished mahogany, the other a 'service car' of polished oak) which, with a press of a button, fly up and down on finest fishing lines – not forgetting the vast array of up-to-the-minute household aids – life below stairs was not half bad.

With all their domestic paraphernalia intact, these quarters of the Dolls' House are perhaps the most bewitching of all. They include such heart-stirring sights as the framed photograph of a 'Tommy' (it was after all only five years since the end of the war) in every

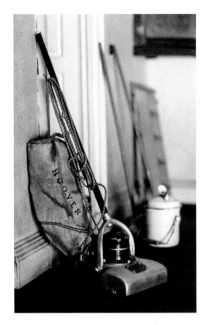

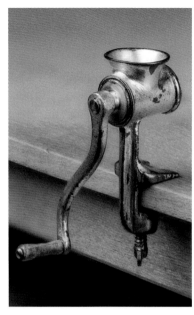

FAR LEFT: The
Hoover in the
Housemaid's Closet.

LEFT: Mincing
machine attached to
the kitchen table.

BELOW: Cleaning
products in the
Housemaid's Closet.

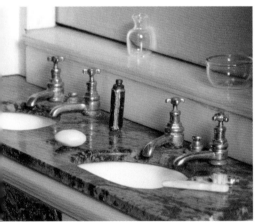

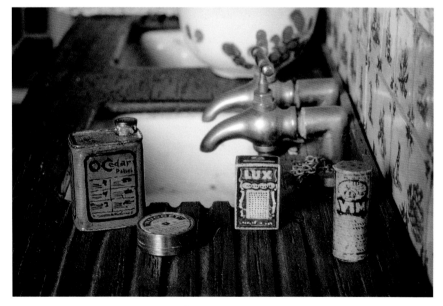

All the rooms are served with hot and cold
running water, from sturdy steel taps in
the working rooms below stairs (RIGHT),
to elegant silver taps in the royal quarters,
as seen in the King's Bathroom (ABOVE).

maid's bedroom, as well as pictures of famous actresses in the Men's, and of course the obligatory portrait of the King or the Queen – all piercing-through-to your-heart evocations of the period.

In the working rooms below stairs, too, many of us will have the happiest march down memory lane, entranced by such sights as the wooden Ewbank Carpet Sweeper, produced between 1910 and 1939, with its cord and rubber corner buffers. As for the unyieldingly sharp and shiny lavatory paper, watermarked 'Bromo' on every sheet – these details afford the oddest little glimpses into the past. With the damp cleanliness of scrubbed draining-boards in the Butler's Pantry, the asphyxiating aromas of Lux Flakes, Sunlight Soap and Vim, O'Cedar Polish and Gospo in the Housemaid's Closet, the block of Lifebuoy soap and the enamel slop bucket on the slate-floored scullery, it seems as if the air that you are breathing is that of 1924, forever trapped within these little walls.

'If we suppose that the present Queen's [Dolls'] House lasts on for, say, two hundred years', wrote A.C. Benson, 'the little mansion which seems positively the last word in convenience and beauty ... we may be sure that our successors will look at it in astonishment,

and wonder that men could ever have deigned to live in so laborious and cumbrous a way ... But at the same time, how they will value the house as an historical document!'

There are many reminders of that 'cumbrous' way: for example, the red cone Minimax Fire Extinguisher – 'Minimum effort, Maximum strength' – invented in Germany in 1902 and established in Britain in 1903; then there is a rather lumpen Hoover – one of the Dolls' House's trail-blazing American imports, which was invented by an Ohio janitor in 1902. The cocktail shaker – one of them awaits use in the Service corridor outside the Kitchen – was also from the United States, gaining popularity there in the late 1800s.

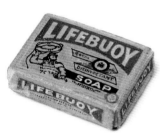

Miniature cardboard box of Lifebuoy soap containing three double bars of yellow soap.

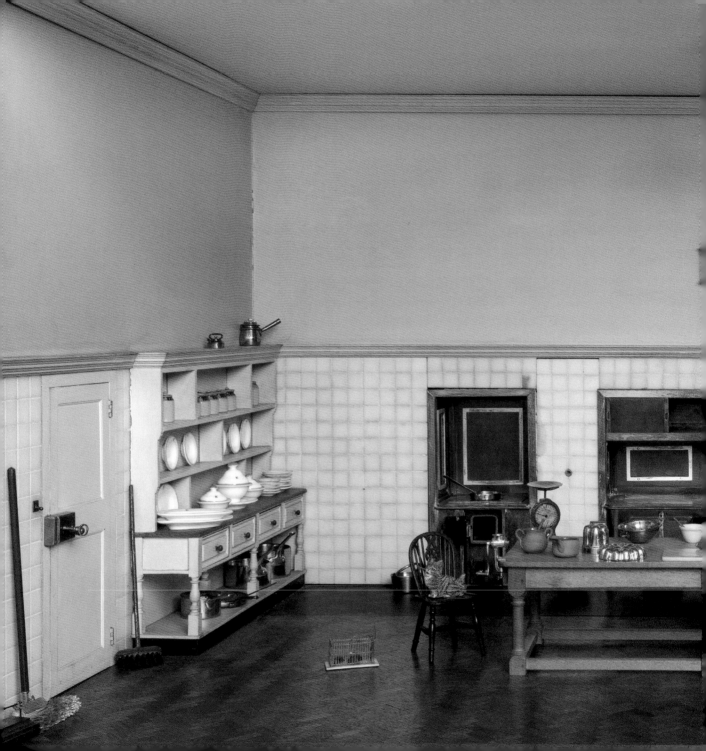

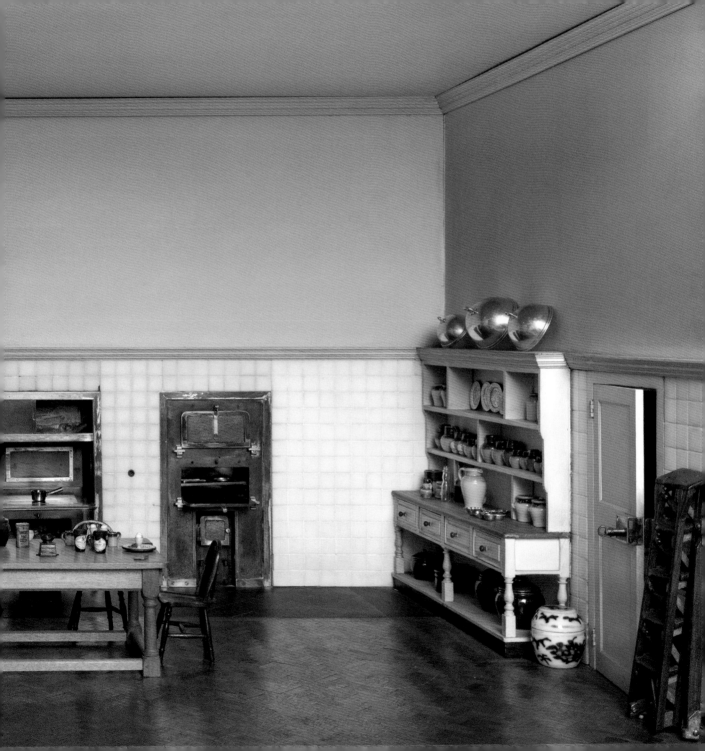

PREVIOUS PAGES: The Kitchen. 'Over all this perfection electric light reigns', wrote Dymphna Ellis – the Kitchen's official chronicler-in-chief, who, providing yet another piece in this great jigsaw of British life, was one of the children photographed by Lewis Carroll in the 1860s – 'and from real glass bulbs, like smallest drops of dew, real light is turned on by real switches.'

BELOW: The copper kettle, forever primed for boiling on the hob, was made from a George V penny, and has the King's head, encircled like a miniature, on the base.

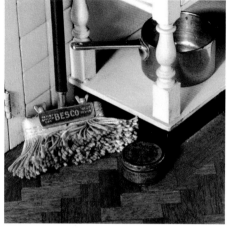

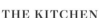

LEFT: The 'labour-saving' Besco Brush Mop – patented in 1923 – has a name plate of pure gold; a right royal exception to the usual brass.

BELOW: With the usual unerring accuracy of Dolls' House design, the floor along the front of this 'English Range' has been paved with slate.

THE KITCHEN

On the south front, wide and welcoming, the Kitchen rules the domestic roost. With its wood-block floor this was 'no painted pretence', in the words of Sir Lawrence Weaver, who was in charge of showing off the Dolls' House at the British Empire Exhibition, 'but two thousand [in fact 2,500] tiny sections of veritable oak ... Here indeed is a paradise for cooks.' Taking centre stage is Lutyens's oak table: 'a symbol of the British constitution ... and contains that council of perfection, a drawer at each end!' enthused Dymphna Ellis, recorder of the Kitchen and stores. A miniature masterpiece by Lutyens, this is identical to one he designed for his own dining room in London.

Jelly mould and rolling pin.

The Dolls'-House Cookery-Book, by Agnes Jekyll.

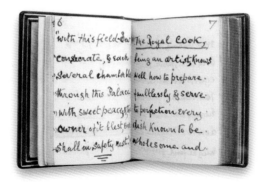

Lutyens's gilded and painted-with-cabbage-roses clock hangs high over the polished steel range, which has smaller and separate ovens on either side; one for heating plates, the other for pastry. All three are as handsome as can be, with 'no theatrical display of electricity', wrote Miss Ellis, 'but good honest British coal producing the good old British smoke, truly described by some far-seeing mind as "the source of Britain's greatness".' And like a guard of honour for the old days, a complete copper *batterie de cuisine*, with correctly tinned interiors, stands proud on the dressers.

Today it is as much of a delight to be able to see all these old household pals as it is to dwell on the minds of those who made them. Many have made it triumphantly through to

the present day: a tin of Colman's Mustard stands on the Kitchen table – first produced in 1814, it still holds the Royal Warrant granted in 1866; Tiptree jam has been on the go since 1885; Frank Cooper marmalade, founded in 1874, is still a holder of the Royal Warrant; while Lea & Perrins Worcestershire Sauce was established in 1836. There are many more, still going strong, contents and packaging almost unchanged since the day they were put in the Dolls' House Kitchen, a century ago.

Agnes Jekyll (1861–1937) – sister-in-law of Gertrude, who designed the Dolls' House Garden – was in charge of the Kitchen stores. Ever sensitive to the trouble that might be created by choosing one firm over another, she wrote to Princess Marie Louise that they would have 'to do this with some caution so as not to give cause for offence or jealousy ... I think it will be well to send the letters to such firms as already supply the Royal Household, or those who are specially eminent in their productions. Space will be limited ... but if Huntley and Palmer contribute, Peek and Frean ... may be embittered at being excluded. If we suggested tea from Twining, some of the other great Tea houses, The Indian Tea-growers and the Ceylon Tea Association, may complain.'

RIGHT: There are singular stars in this culinary extravaganza, which send you spiralling back in time; none more so than the great round wooden knife machine – 'Kent's Patent 199 High Holborn, London' of 1870 – designed to clean steel knives but already old-fashioned by 1924, by which date stainless steel cutlery was in widespread use. Up to twelve knives could be dealt with at a time, pushed into slots and cleaned and polished by leather blades, felt pads and bristles. Whilst pouring abrasive emery powder into the drum, you crank the handle round, often with the dire result of wearing the blades to razor-blade thinness.

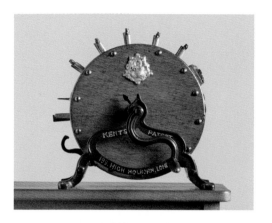

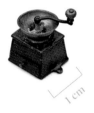

LEFT: There is also a wood-handled coffee grinder, which can be scrunched into life; with a base only 1cm square, it was described by our poetic Miss Ellis as 'a gem of the rarest water' with the drawer for the grounds having 'the smallest knob in the whole establishment or indeed, I venture to say, in the whole world!'

1 cm

As well as picking her way through this minefield of good manners, Agnes Jekyll also wrote *The Dolls'-House Cookery-Book* for the Library. 'The Royal Cook,' she wrote, 'being an artist, knows well how to prepare faultlessly & serve to perfection every dish known to be wholesome and nourishing, and pleasant both to the palate and to the eye.' For breakfast she recommended brioches with cups of frothed chocolate, and a touch of whipped cream; for 'a festive tea party' she proposed a Chelsea bun as well as a Russian ice of blackcurrant leaves. Pleasing proof of her influence is to be seen in the large Chinese jar for lavender, for which she had the following aromatic suggestion: 'To sweeten the atmosphere before the guests assemble, and after savoury dishes have been prepared. Heat a shovel, or any such metal surface, very hot, and strew on it dried heads of lavender; the air will soon smell deliciously of that fragrant plant.' Last but not least in this engine room of the Dolls' House, three ivory mice in a humane mouse-trap are forever desired by a crystal cat.

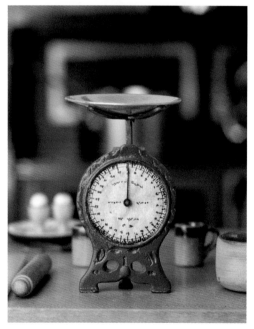

Weighing scales.

THE LINEN ROOM

'The store of linen might gladden any housewife's heart', wrote A.C. Benson. So it most certainly should, with its cupboard-lined room – 31½ feet (9.6m) long in human scale – placed right in the centre of the top floor, thus giving the royal housekeeper her rightful role in the hierarchy of the house. Doubling as her sitting room – in which that most reactionary of newspapers *The Morning Post* is on hand to read – it is a particularly soothing spot, with a hand-woven Chinese carpet, marble fireplace and iron hob grate.

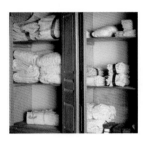

ABOVE: This quantity of linen was deemed essential, allowing every item to 'rest' between laundering and use.

RIGHT: Here again, America has marched to England's aid, with the treadle Singer Sewing Machine. Invented by Isaac Merritt Singer in 1850, here it is, in all its silvered, gilded and mahogany glory.

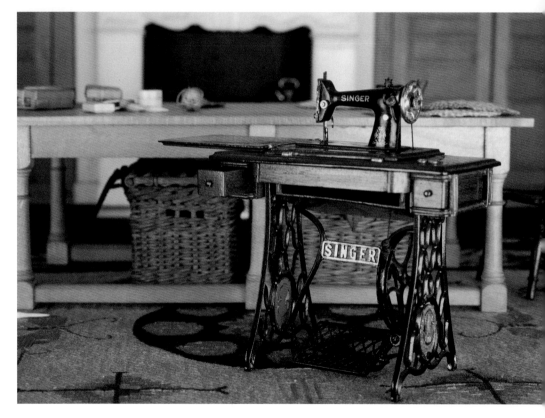

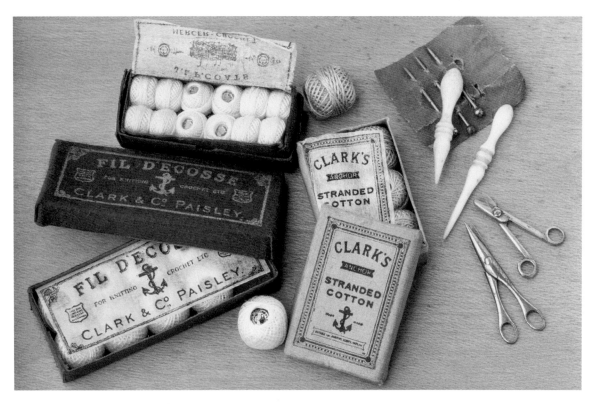

LEFT: Wicker hampers – so large when life-size as to have to be carried by two men – stand ready for the laundry.

RIGHT: The electric iron stands proud, also having crossed the Atlantic after it was invented by Henry W. Seely in New York in 1882.

ABOVE: The supplies of Clark's Cotton – wrapped in blue embossed tissue paper within their blue boxes – came from Paisley in Scotland.

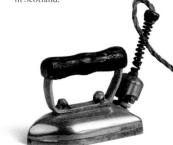

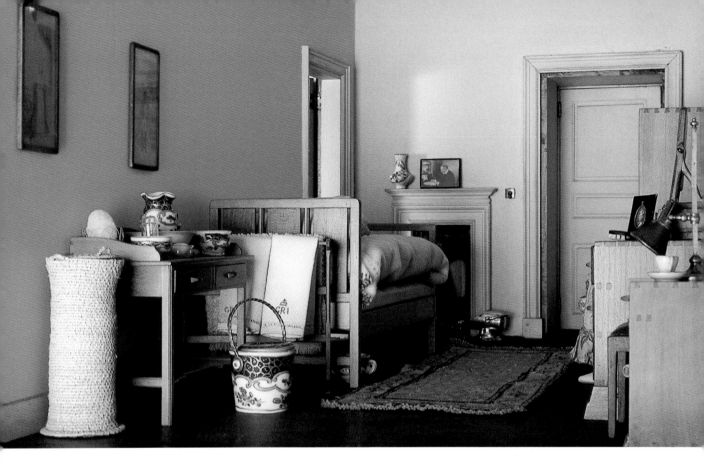

The Housekeeper's Room.

THE SERVANTS' QUARTERS

Adjoining her linen kingdom, the Housekeeper's Bedroom is furnished with an importance equal only to the Butler's. It is the very ordinariness of these rooms that makes them so special in their survival – few, if any, such authentic rooms are left in the land today. They show us such long-lost sights as stern iron bedsteads with flock mattresses on wire springs, along with military brushes and Odontasse toothpaste, bottles of Eno's Fruit Salts (invented in Newcastle in the 1850s by James Crossley Eno) as well as razors less than ½ inch (1.2 cm) long. And chamber pots are to be found under every bed.

All the Men's bedrooms have trouser presses. These, and much of the other furniture – wood, good and solid – was made by the great firm of Waring and Gillow, with holly-wood beds and horsehair mattresses for the more senior staff, and the Butler being honoured with a fine suite in unstained cherry-wood, designed by Lutyens himself.

The paintings, drawings and prints for these rooms, often by artists of note, were obviously given careful consideration; none more so than the powerful First World War painting *Big Guns to the Front* by the equestrian artist Lucy Kemp-Welch (1868–1958), hung on the walls for 'Man Number 4'. The Butler was favoured with a painting of Edinburgh Castle by Frank Moss Bennett (1874–1952). Bennett's painting in 'Maid's Bedroom Number 3', as well as his *Tower of London* in 'Man's Bedroom Number 4'

CLOCKWISE FROM TOP LEFT: Eno's Fruit Salts, chamber pot, razor and Odontasse toothpaste.

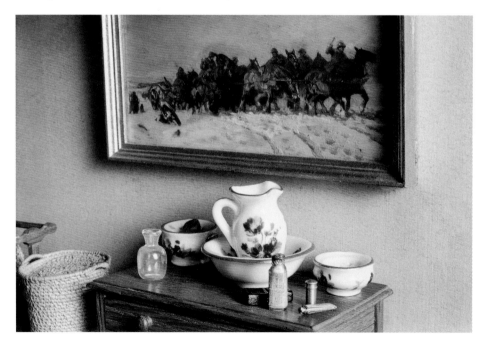

Big Guns to the Front by Lucy Kemp-Welch, hanging in the bedroom of Man Number 4.

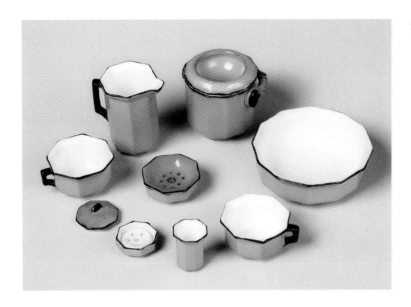

3 cm

ABOVE: All the staff bedrooms
have variations of the same
Cauldon Pottery washstand
sets, comprising wash bowl,
jug, tooth mug, slop bucket
and sponge and soap bowls.
The Butler's set (pictured
here) is the same as the
Princess Royal's.

7 cm

RIGHT: Much of the
furniture, including the
men's trouser presses,
was made by Waring and
Gillow. Founded in 1897,
after the merger of Gillow
of Lancaster and Waring of
Liverpool, this firm was so
popular with the swells that
it was parodied in Gilbert
and Sullivan's *HMS Pinafore*.

are happily a world away from his usual
genre paintings of cardinals, huntsmen
and bewigged heroes; hugely popular
in the 1920s, these have now thankfully
vanished with barely a trace.

Such details constantly flummox
you into thinking this must be a real
house. With a fire in every servant's
bedroom – albeit having to be lit, along
with all the others in the House, by the
maids in the early hours of the morning
– these would have been cosy quarters.
Reading material for the servants took
the form of *Country Life*, as well as the
highbrow *Pearson's Magazine*, which
in 1922 was the first in the country to
publish a crossword puzzle.

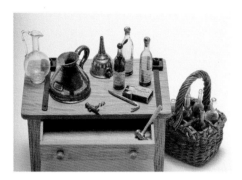

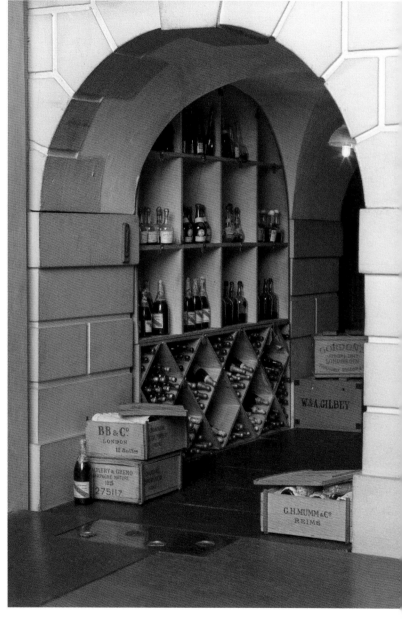

TOP: The Wine Cellar was the Butler's domain. All the impedimenta required for such duties as decanting here await him.

ABOVE: Another important daily duty would have been to keep the Cellar Book in order. Under columns of Received and Consumed, this little volume records that in 1923 two dozen bottles of Château Lafite 1875 were bought from Berry Bros for 200 shillings a dozen.

RIGHT: The Wine Cellar.

The Trunk Room throws up yet more memories, with its assembly of luggage in pigskin, snakeskin and crocodile, as well as tin and even wood. There are portmanteaux, as well as hat, boot and book boxes, a 'Mannequin Box' and tube for umbrellas.

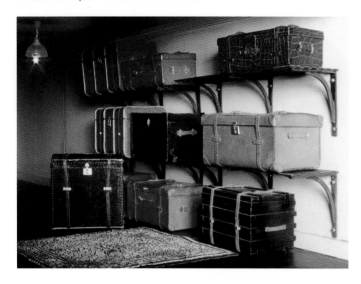

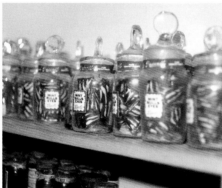

Jars of mint Bull's Eyes sweets in the Dry Goods Store.

THE CELLARS

For those who delight in such domestic details, what is to be found in the Cellars will set them hollering with joy. Descending steep stairs, into nine dimly lit groin vaulted corridors of rusticated 'stone' (as with the exterior, in fact painted wood), is to be submerged yet again in the very essence of the age. In the Dry Goods Store, so ample, according to A.C. Benson, 'that the house could be victualled to last out a moderate siege', memories are stacked high alongside bottles of 'Bull's Eyes' and 'Barley Sugar'. Your taste buds tingle too with 'Maltex... Invigorating and Nutritional'.

The Wine Cellar is another sight for sore eyes with its one hundred dozen bottles of the finest champagnes, wines and spirits and beers; all laid down in their wooden honeycomb compartments and on the shelves of their noble vaulted quarters. They were chosen with all the care and expertise worthy of the Royal Household by Francis Berry, senior partner of Berry Bros of St James's Street in London, a firm founded in 1699 and today Britain's oldest wine and spirits merchant. Although somewhat evaporated, they could even today be ecstatically tasted on the tip of the tongue.

INVENTORY OF THE WINE CELLAR

QUANTITY	VINTAGE
Champagne	
5 dozen	Veuve Clicquot 1906
5 dozen	Pommery & Greno 1915
5 dozen	Louis Roederer 1911
5 dozen	G.H. Mumm & Co. 1911
2 dozen	G.H. Mumm & Co. 1911 (magnums)
Claret	
2 dozen	Château Lafite, Grand Vin 1875
2 dozen	Château Haut-Brion 1888
2 dozen	Château Margaux 1899
2 dozen	Château Le Prieuré 1918
Port	
2 dozen	Cockburn Smithes & Co. 1878
2 dozen	Taylor Fladgate 1896
2 dozen	Warre 1900
2 dozen	Fonseca 1908
2 dozen	Dow 1912 (magnums)
2 dozen	Royal Tawny
Sherry	
2 dozen	Amoroso Pale Golden
2 dozen	Oloroso Puro 1872
Madeira	
2 dozen	Finest Bual 1820
2 dozen	Chablis-Moutonne 1904

Case and bottle of Louis Roederer Champagne.

QUANTITY	VINTAGE
White Burgundy	
2 dozen	Montrachet 1889
2 dozen	Graves-Supérieur
Sauternes	
2 dozen	Château Yquem 1874
Burgundy	
2 dozen	Romanée 1904
Hock	
2 dozen	Rudesheimer
French Vermouth	
2 dozen	Noilly Prat (litres)
Italian Vermouth	
2 dozen	Martini Rossi

Martini Rossi vermouth.

3.1 cm

Spirits

2 dozen	Grande Fine Champagne Brandy 1854
1 dozen	Hennessy's Brandy
2 dozen	Dry London Gin
1 dozen	Fine Old Jamaica Rum

Scotch Whisky — ¼ cask 28 gallons G. & J.G. Smith's Glenlivet 1910

Irish Whisky — J. Jameson & Sons, Dublin 1907

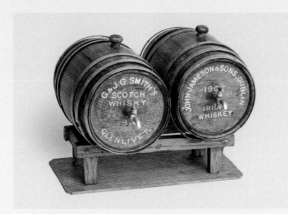

Also, 1 dozen of each of the following, all 'bottled' by Berry Bros & Co.:

Pères Chartreux Litres Yellow

Benedictine, D.O.M.

Riga Kummel, Fleur de Cumin

Sloe Gin

Cherry Brandy

Apricot Liqueur

Crême de Menthe, Cusenier

And:

1 dozen	Gilbey's Champagne Brandy
1 dozen	Gilbey's Whisky
2 dozen	Gilbey's Tawny Port
1 dozen	Château Laudenne
1 dozen	Vintage Claret
12 dozen	Bass' Pale Ale
5 dozen	Bass' King's Ale
2 casks	Bass' Pale Ale
2 cases	Gordon & Tanqueray's London Gin
1 dozen cases	'Johnnie Walker' Whisky

Bass ale.

2.6 cm

INVENTORY OF FOOD STORES

1 chest of Tea

2 packets of Tea

2 tins of Coffee

1 dozen tins of Cocoa

4 dozen tins of Condensed Milk

1 tin of 'Milkal'

2 dozen jars of Jam

18 jars of Marmalade

1 packet of Jelly Cream

2 bottles of Vinegar

2 bottles of Salad Oil

6 bottles of Lime Juice

4 dozen boxes of Chocolates

2 cases of Chocolates

6 tins of Gums

6 tins of Toffee

6 bottles of 'Bulls' Eyes'

6 bottles of 'Maltex'

6 bottles of 'Saltines'

6 bottles of Barley Sugar

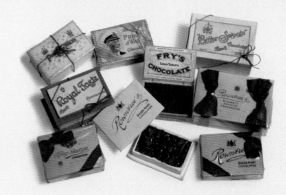

THE GARAGE

Life for the royal chauffeurs in the Dolls' House Garage would have been lived at the cutting edge of motoring design, with cars that gleamingly proclaimed the supremacy of British motor manufacturing in the 1920s. Six of the all-time greats are on parade – all with real engines that would go 20,000 miles to the gallon. They are the Daimler limousine and station wagon, the Lanchester limousine

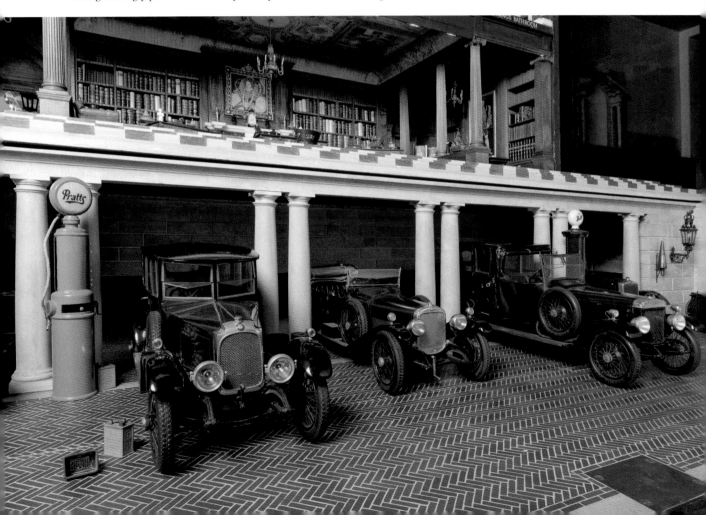

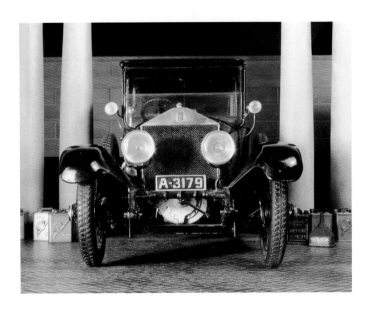

(the firm made the first petrol car in Britain in 1895), the Sunbeam Open Tourer and the five-seater Vauxhall, as well of course as the Rolls-Royce – the 1923 Silver Ghost seven-seater limousine landaulet. During these early days of their production, cars were the prerogative of the very rich, who would have ordered customised models. So it was with the monarch's fleet; in the royal livery colours of black and maroon, each one emblazoned with either the gilded royal cipher or coat of arms.

As with stables attached to fine houses, so the Garage for the horseless carriages is here given its full architectural due, with a 'stone' colonnade and rusticated walls, a 'brick' (stencilled) herringbone floor, and a wooden 'inspection pit'. From the all-star line-up, only Vauxhall remains intact, having escaped the various fates of collapse, merger or foreign

The diminutive Rolls, a de luxe version of what was generally acknowledged to be 'The best car in the world', weighs a mere 4lbs (1.8kg), while its full size counterpart weighs 5,200 (2,359kg). The most alluring of the vehicles, it is fitted with sumptuous blue brocade upholstery.

A calendar for 1924 hangs on the wall of the Garage.

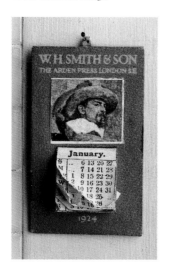

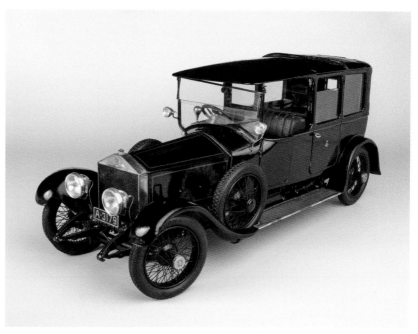

Rolls Royce Silver Ghost seven-seater limousine landaulet, 1923. The interior includes attached silver topped flasks.

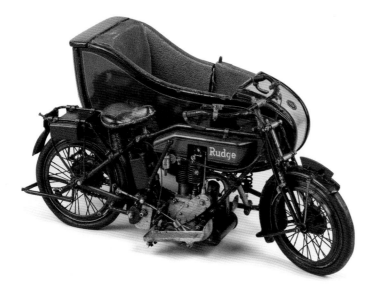

A splendid addition to the Dolls' House Garage is the Rudge motorcycle with its luxurious leather-clad side-car. Also to be found here are the Rudge-Whitworth 'Lady's and Gentleman's Pedal Bicycles'. 'Rudge it, do not trudge it' was the slogan for the firm that started as a bicycle manufacturer in 1868 and went on to produce motorbikes from 1911 to 1946. The Second World War brought its glory days to an end.

takeover. Yet here they all are together, as pristine as the day that they were created – in the surroundings, too, that they would have enjoyed in their heyday.

Among the host of ghosts in the Queen's Dolls' House, none evokes more knee-weakening nostalgia than these domestic details; too commonplace in their day to be thought worthy of preservation, yet of such huge and intimate importance to our everyday lives that to see them all again stirs memories of the deepest water.

Harold Nicolson, in his book *The Detail of Biography*, written for the Dolls' House Library, touches on this:

How rare to the biographer are … gifts of really illuminating detail. Too often does the letter-writer stop short of the essential revelation. Byron himself, most vivid of self-recorders, is guilty at moments of such discrepancies. He tells us of his tooth-powder – he does not tell us of his brush. Or what the Russian oil smelt like, or where he put his paper basket, or spat the tobacco that he chewed. Such are the little gaps and incompletenesses which the biographer of today has to bridge and rectify. And as I contemplate the precision and amplitude of the Queen's Dolls' House, and note how in each detail it reflects the life of an English gentleman of 1923, I am stirred with envy for the biographer of 2023. The works of art, the shaping of the rooms, the furniture, the books even, could be derived from other collections. But with what illumination will he, the future biographer, gaze upon the detailed domestic appliances of 1923!

2.7 cm

Can of Shell Motor oil.

There are two private petrol pumps: Shell and Pratts, the latter the firm that introduced the petrol can to Britain and whose fuel was described as 'The Essence of Refinement'. In 1928 it was to be subsumed by the parent company Esso.

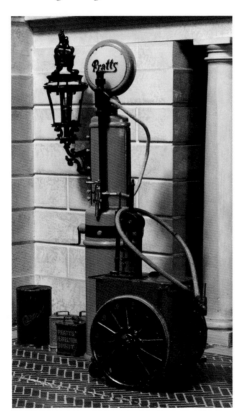

ABOVE STAIRS

When, 55 years ago, Sir Edwin Landseer Lutyens was born, the world was enriched by a new wonder: an eternal child, an apostle of beauty, an apostle of thoroughness, a minister of elvish nonsense all in one ... he builds the Queen's Dolls' House, an affair of inches, but such an affair as not even the Japanese cherry-stone carvers could excel ... this minute but splendid abode lacks nothing that a big house would have, and really is such a home as the King and Queen might fittingly inhabit, were some enchanter suddenly to diminish them ... It is as complete and exquisite a model of twentieth century residence as art and craft and devotion could contrive.

E.V. Lucas
Everybody's Book of the Queen's Dolls' House, 1924

OPPOSITE: The King's Bedroom is gazed over by his daughter, the Princess Royal, painted by Ambrose McEvoy.

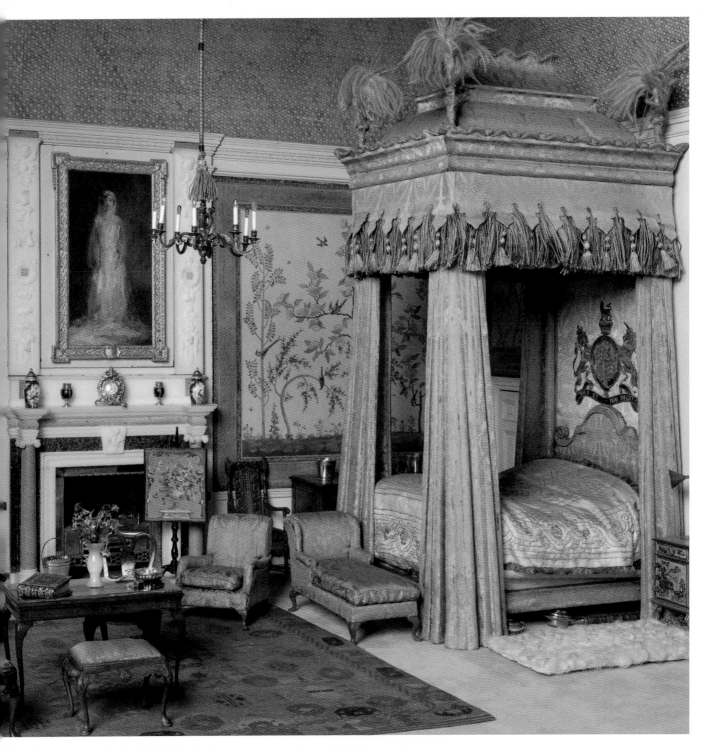

Lutyens had delighted in the historic potential of the Dolls' House, enthusing from the start that he would 'devise and design something which for all time will enable future generations to see how a King and Queen of England lived in the twentieth century, and what authors and artists and craftsmen there were during their reign'. In homage to 'Mary, Britain's Domestic Queen' – as she was called in *The Times* in 1923 – he determined that it should be a home rather than a palace, albeit a very grand home, rich with royal allusions. To that end he applied his architectural wizardry, and above all to the royal apartments. Lofty chambers rising two and three storeys through the main and mezzanine floors, the sombre Library and the shimmering Saloon both stretching across the width of the building, these rooms have an exalted yet comforting air. The cosiest and most elevated of all, however, are the royal bedrooms with their brocade-hung 'eighteenth-century' four-posters, sprouting ostrich-feather plumes as they soar skywards to cloud-painted ceilings.

All tiny anthems to the cultivated taste of the times, there are few such decorative survivals as these little rooms in the country. Most large houses built or done up during

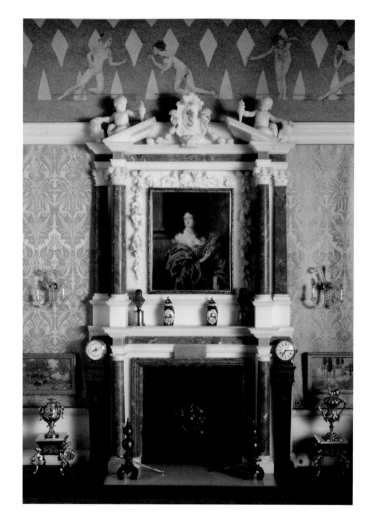

Whichever coloured marble was used to fashion the fireplace, so the room would be designed in harmony about it. Thus, while the 'Indian Yellow Marble' in the King's Bedroom gave golden tones to the wall and ceiling paintings, in the Saloon the pink-pillared fireplace and overmantle ensured that the room was hung with rose-coloured damask (pictured above, now faded to gold). Woven in dolls' house dimensions, this has 120 silken threads to an inch, costing the princely sum of £80 – about £4,000 today.

this period, with a rich mix of the old and new (eighteenth-century chairs drawn invitingly together in the middle of the room rather than placed with stiff formality around the walls, for example), have not been considered serious enough to warrant meticulous preservation; whilst any earlier houses that were redecorated in the 1920s have for the most part been stripped back to their 'original' state by the sterile hand of scholarship.

The Queen's Dolls' House was built so as to preserve an aspect of our nation's history for all time. This was how life was led by the British Royal Family and their fellow grandees, before the First World War ruptured their lives, customs and country for ever. It is with surreal success that time has been arrested within this little building.

As Lutyens lamented that his grand New Delhi schemes were to be the architectural swan-song of the Empire, so he hoped that the Dolls' House would be a 'good tune well sung'. Building for the Queen, he could be in soaring operatic voice, with all the freedom to fulfil his most heartfelt dreams. The miniature scale allowed him to indulge his architectural fantasies without fear of charges of ostentation and extravagance; and in any case, it had been agreed that every object

should be donated and that there should be no fundraising on the grand scale. In the event, Lutyens did 'land a fish' or two in the way of generous sponsors. He also, unknown to his wife, loaned £6,300 of his own money, which, according to his daughter Mary, made him 'always rather fearful of death before repayment'. With pre-War opulence now out of the question in everyday life, in the Dolls' House it could be revived in full measure, although always, Lutyens determined, with the tempering touch of having been designed as the monarch's domestic rather than official residence.

THE HALL

Royal life 'above stairs' was bound, of course, to be rarefied, and would have been surrounded by the work of the most dazzling illuminati of the day. From the moment you step into the Hall, with its white and pink marble walls, shining white marble stairs and silvered balustrade, you are in good company, with the finest output of arts and crafts that the country could produce – company that will keep you entranced in every room. The bronze Venus at the foot of the staircase was sculpted by Francis Derwent Wood (1871–1926), whose work is to be seen throughout

the British Isles, while the foremost authority on decorative ironwork, John Starkie Gardner (1844–1930), fashioned the Dolls' House's silver stair balustrade.

Sweep up the stairs and you can shake the hand of the nation as it were, with King Edward VII and Queen Alexandra, sculpted by Sir William Goscombe John (1860–1952), the Welshman responsible for innumerable figures worldwide, including Sir Arthur Sullivan in St Paul's Cathedral and the Titanic Memorial to the Engine Room Heroes in Liverpool. From niches on high it is the First World War heroes who stare forth: Earl Haig and Earl Beatty, by the official war artist C.S. Jagger (1885–1934), who also sculpted the Royal Artillery Memorial at Hyde Park Corner (see p.22).

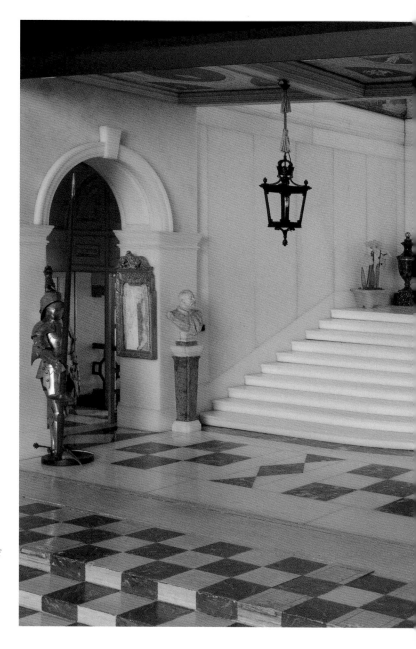

The Entrance Hall. The celestial ceiling panels were painted by Bridget Guinness, a British woman who, of all things, founded the Pekingese Club of America. The sculptor of the bronze Venus was Frances Derwent Wood, whose work can still be seen across Britain, from figures on the roof of Kelvingrove Art Gallery in Glasgow, to the great *David* on the Machine Gun Corps Memorial at Hyde Park Corner in London. J. Starkie Gardner was not only responsible for the Hall's silver balustrade, but also for the great gates of Holyroodhouse.

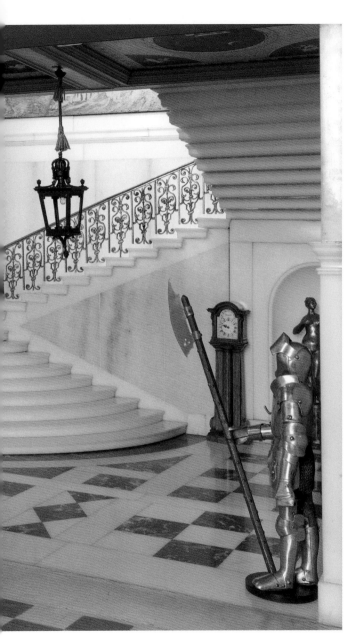

The longcase clock, designed by Lutyens – but made and given by Cartier – has a face and movements copied from an example by the seventeenth-century clockmaker Thomas Tompion.

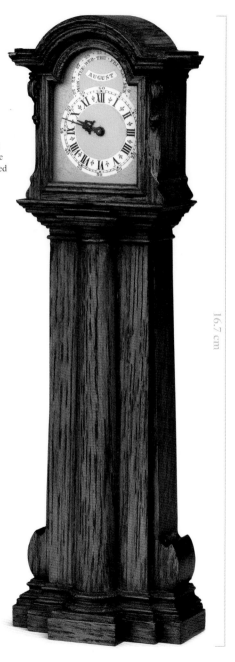

16.7 cm

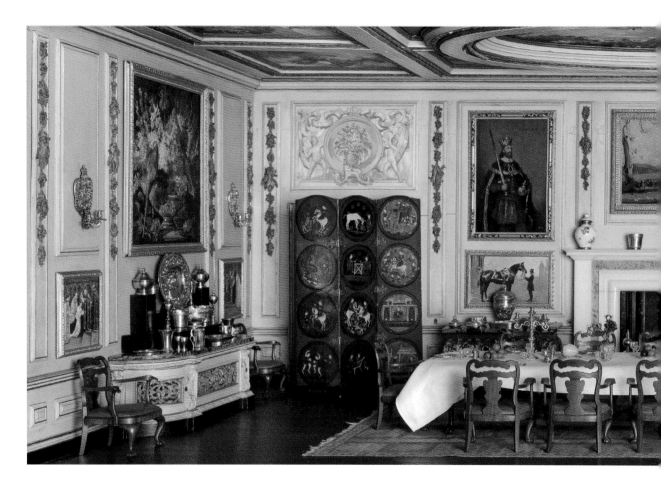

THE DINING ROOM

Despite George V and Queen Mary living, in the Queen's words, a 'Darby and Joan' existence by the 1920s (dining alone together each night, in stark contrast to the jazzed-up lives of so many of their subjects), the Dolls' House Dining Room was lavishly appointed for entertaining on the grand scale. 'It is a room where parade rather than nourishment is the first consideration' wrote William Newton, the then editor of the *Architectural Review*. Over the doors are paintings by Gerald Moira in imitation of plasterwork, while carved limewood festoons tumble down the walls in the style of the late seventeenth-century wood carver Grinling Gibbons.

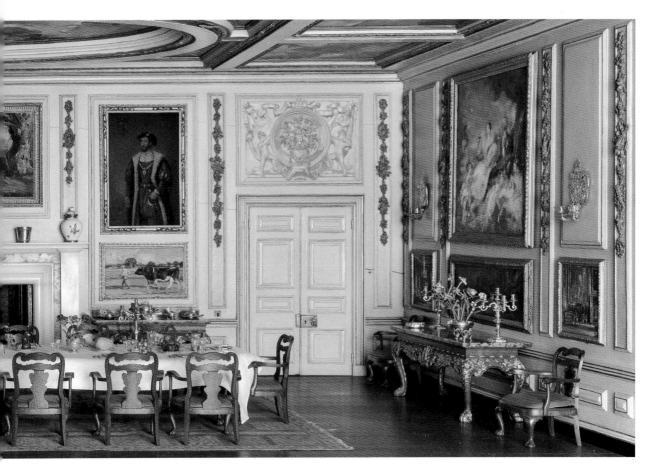

The list of items for the Dining Room included 48 champagne glasses, 24 oyster forks, 24 finger bowls, 2 pairs of asparagus tongs and 6 slop basins.

The 18 walnut chairs, their arms carved with the head of an eagle, were designed in the style of the early 1700s. This chair sits below a portrait of King George V at his coronation by Alfred Pearse.

Lutyens's carved buffet groans with gold and silver of the 'sixteenth, seventeenth and eighteenth centuries', as too do the 'early eighteenth-century' side tables – 'their legs being exquisitely carved, gilt at the shoulders with lion masks no larger than a sweetpea seed', according to Percy Macquoid (1852–1925), who arranged much of the furniture.

Paintings hang densely on the walls, and range from the portrait of Edward III by Sir William Llewellyn (1858–1941), to the more contemporary works of Alfred Munnings,

The 18 walnut chairs, their arms carved with the head of an eagle, were designed in the style of the early 1700s. This chair sits below a portrait of King George V at his coronation by Alfred Pearse.

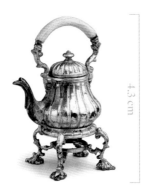

4.3 cm

Kettle and stand 1924. The Dolls' House contains a silver dinner service for 18 people. It was made by Garrard and Co. Ltd, the Crown Jewellers from 1843. The service includes everything from mustard pots and cutlery to this silver kettle.

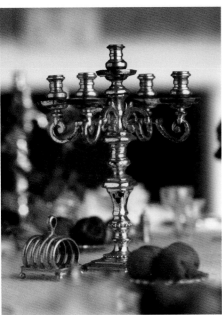

Candelabrum
and toast rack.

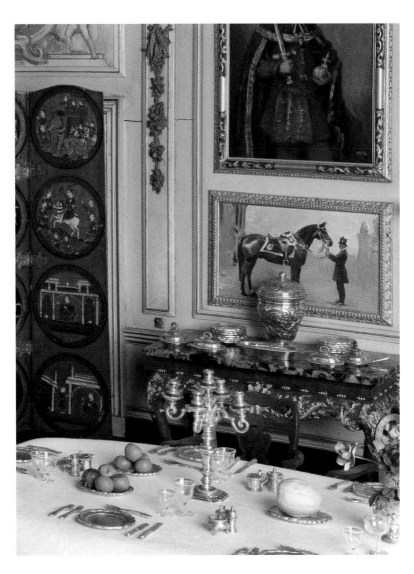

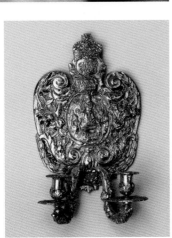

White metal wall sconce, with
a crowned *WMR* monogram,
and a central cartouche of the
Judgement of Solomon.

Ambrose McEvoy's miniature version of
Franz Xaver Winterhalter's 1846 painting
of Queen Victoria and her family.

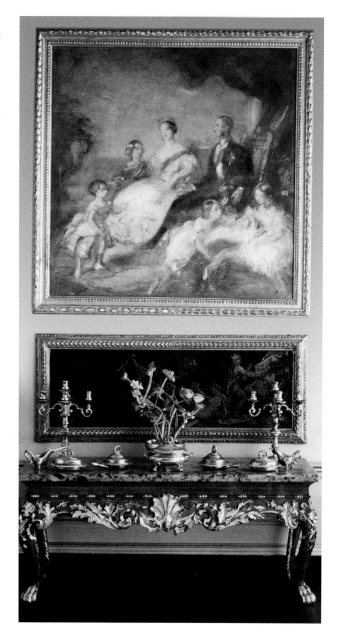

including *The Prince of Wales on Forest Witch*,
showing the pink-coated Prince on his chestnut
horse, which hangs above the fireplace,
while below is a painting of a hefty-looking
Prize Bull, as well as one of Delhi, the King's
Charger. Looming large is a copy by Ambrose
McEvoy (1878–1927) of Winterhalter's 1846
painting of Queen Victoria with Prince Albert
and their children.

A room to feast in, it is also a feast of the
decorative arts in itself: the silver wall sconces
are miniature copies of originals at Windsor,
while standing at the door to hide arrivals
from the Kitchen is a red-lacquer screen,
designed by Lutyens and made by Cartier out
of real eighteenth-century circular Indian
ganjifa playing cards.

The carpet, which reflects the lines
of the richly decorated ceiling panels,
was painted, rather than woven, in the
Aubusson style by the actor Ernest Thesiger
(1879–1961), who was to play the sinister
Dr Septimus Pretorious in *The Bride of
Frankenstein* (1935). Thesiger's prime passion
was in fact needlework, but he also painted
the silk fire screen in the King's Bedroom.

The fading rays of the Empire were
discreetly absorbed into the state rooms, to
be seen as examples of royal taste rather than

the trumpetings of imperial glory, yet India's presence is keenly felt within these rooms. *The Times of India* lies ready for the King to read in the Library, on the shelves of which you find the enchanting Indian tale about the god Krishna, *The Flute-Player's Dolls* by Cornelia Sorabji (1866–1954) – academic, lecturer, social reformer and the first female Indian barrister. Richest of all the Indian contributions were the marble and minerals that were given by the Indian Government.

There are also echoes of China in umpteen little objects, such as the tiny jade duck, as well as the Cartier clock designed in the chinoiserie style by Lutyens. Both these are in the Queen's Bedroom, and both accurately mirror Queen Mary's taste. The secondary staircase, a little extra spine supporting the building, is also in the East Asian inspired style. Most obvious of all, in the King's Bedroom, are the painted panels of birds and blooms emulating seventeenth-century Chinese wallpaper, while the many Chinese lacquer cabinets – all the rage in the eighteenth century and again in the twentieth – add considerably to the authenticity of

BELOW LEFT: This carpet was woven by the 'Weaving School for Crippled Girls', Stratford-upon-Avon. The school was founded in the 1890s to teach weaving at the handloom, spinning, carding, dyeing and tapestry.

BELOW RIGHT: The secondary staircase.

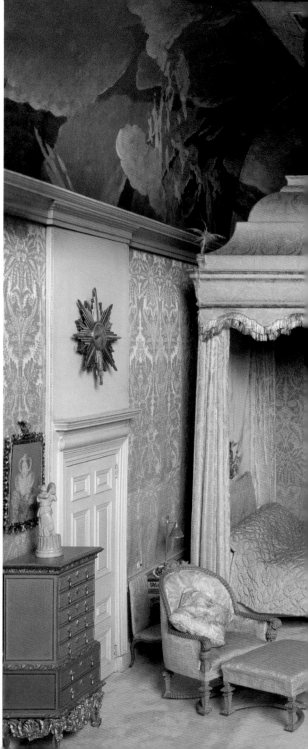

ABOVE: Over the door of the King's Bedroom a swan-necked pediment of exceptional finesse, carved with blooms writhed around a royal ciphered cartouche, is topped with a golden crown.

RIGHT: The Queen's Bedroom, feauring the ceiling painted by Glyn Philpot.

RIGHT: Miniature bracket clock of gilt metal and dark blue enamel case, made by Cartier occupies pride of place on the mantelpiece.

3.2 cm

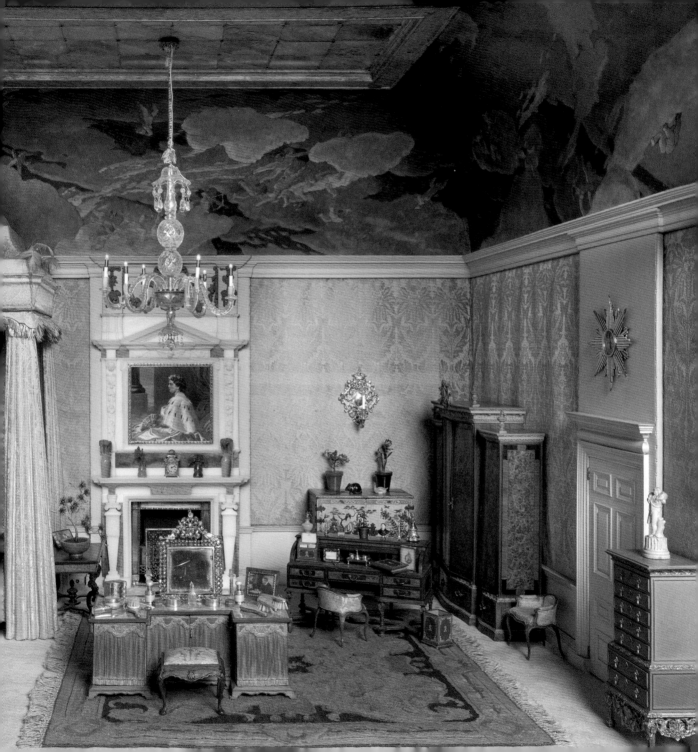

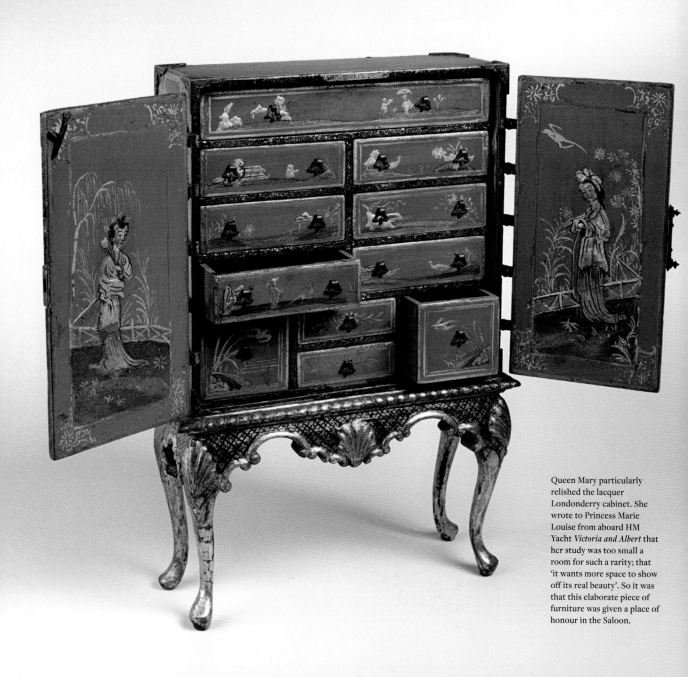

Queen Mary particularly
relished the lacquer
Londonderry cabinet. She
wrote to Princess Marie
Louise from aboard HM
Yacht *Victoria and Albert* that
her study was too small a
room for such a rarity; that
'it wants more space to show
off its real beauty'. So it was
that this elaborate piece of
furniture was given a place of
honour in the Saloon.

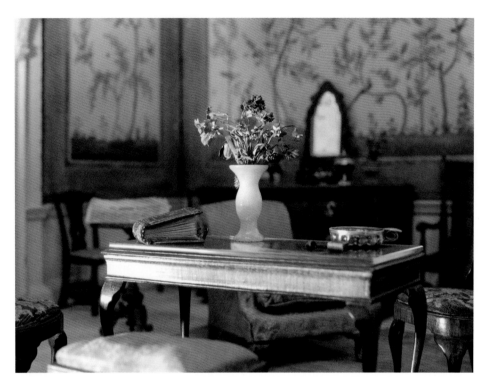

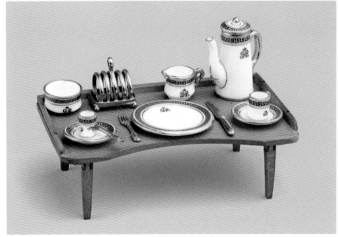

this being a grand house of the 1920s. In the Saloon, a particularly elaborate cabinet in scarlet, gold and black on gilded legs, was copied exactly from one in Londonderry House, and was given by the Marchioness of Londonderry. What a thrilling subject for sleuthery, discovering how many of these diminutive treasures can be found full-size!

Specific royal references are surprisingly few and far between in the state rooms; although two thumping great silver-gilt thrones, very like those that Lutyens was designing for Delhi (albeit 1 inch high), give

the Saloon a most regal air; as do all the gold crowns, set beguilingly atop the gold frames of the royal portraits.

Most overtly monarchic of all, of course, are the Crown Jewels, safely behind the grill gates of the Strong Room. Weighing 1½ lbs (680g), instead of 1½ tons, the gates are replicas of those with an 'ingenious locking bar' (in full working order) made by the Chatwood Safe Co., founded in 1855. Crowns for the King, Queen and Prince of Wales stand proud – Queen Mary wore her jewels with ample aplomb –and there are two orbs, a sceptre and the sword of state, as well as two pairs of spurs and a pearl necklace. Gold and silver plate for the dining-room table is piled high. With the two royal coats of arms on the house's exterior, and the sight of Lutyens' crown-topped wrought-iron lanterns in the front Hall, you are on your royal – yet often homely (and always decidedly English) – way.

BELOW: Another gleamingly interesting object is the minuscule replica of the Indian Koh-i-nûr diamond in the Imperial State Crown, in the Strong Room. Dating from ancient times – some say as early as 3000 BCE – the actual Koh-i-Nûr was the largest known diamond in the world. By the 1830s it was in the Punjab, which in 1849 was proclaimed part of the British Empire. The diamond was subsequently surrendered to Queen Victoria in 1849. Her daughter-in-law, Queen Alexandra, was the first to amalgamate it into the Crown Jewels and it was set into Queen Mary's crown between 1911 and 1936, then reset into a new crown for Queen Elizabeth, consort of King George VI. The crown sits amid the rest of the splendour in the Strong Room.

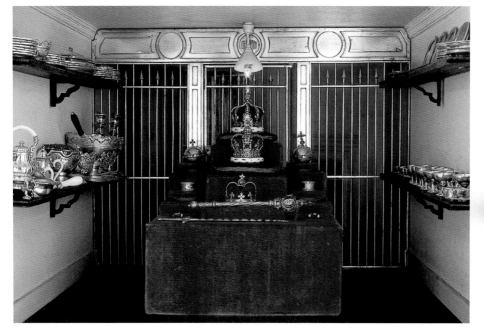

The Strong Room.

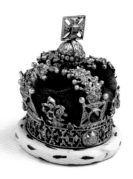

3 cm

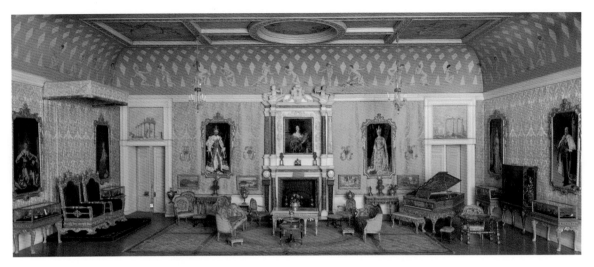

ABOVE: The Saloon.

RIGHT: Throne chair made of silvered wood, upholstered in red velvet.

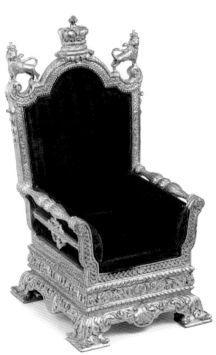

THE SALOON

There are no concessions to ease in the palatial Saloon, with its showpiece suite of eight chairs and two sofas in the stiff style of Louis XV, covered with the finest *petit point* in imitation of Aubusson. The many millions of stitches on furniture less than 3 inches (8 cm) high were embroidered by a Mrs de Pennington. It is the grand piano, though, that is the great delight. Designed by Lutyens, it was made by John Broadwood & Sons and painted by Thomas Matthews Rooke (1842–1942) with sensational Pre-Raphaelite effect in the manner of Edward Burne-Jones, whose chief assistant Rooke had been for 30 years. He had already painted a full-size grand piano (now in America) in 1880 in the style of his great master. This must have caught Lutyens's eye; it was at his request, no doubt, that the *G* and *M* were painted over

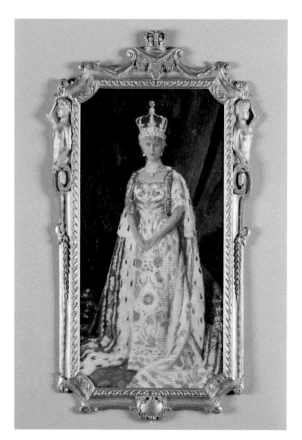
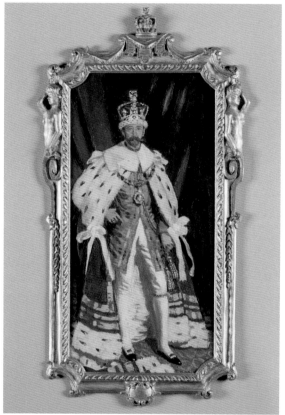

This full-length portrait of Queen Mary and its pair, of King George V, are installed either side of the fireplace in the Dolls' House Saloon. They flank an overmantel portrait of Electress Sophia of Hanover. Portraits of King Edward VII and Queen Alexandra, and George III and Queen Charlotte, hang on the surrounding walls. Queen Mary is depicted in her full Coronation garb, which included a bespoke silk satin dress with thick gold embroidery, an ermine and purple velvet mantle, a diamond choker and a crown. Although the artist may have looked to Queen Mary's full-scale State portrait by William Llewellyn, the pose and attire seem to have been copied from photographs taken of Queen Mary for the Coronation in 1911.

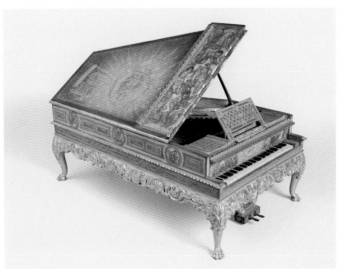

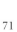

RIGHT: Miniature
burr walnut clock
and barometer each
surmounted by gilt metal
and *verre eglomise* case.

LEFT: The grand piano
with painted decoration
by Thomas Matthews
Rooke.

BELOW: The sofas and
chairs of the Saloon are
exquisitely embroidered
in miniature stitch.

the keyboard. Strange to say, neither this nor
the nursery piano, by virtue of their size, ever
needs tuning.

Here the crown-topped and gilt-framed
portraits of the King and Queen by Sir
William Orpen (1878–1931) have such majesty
as to defy belief in their not being full-size.
The recently knighted Sir William, like so
many artists who worked for the Dolls' House,
had been appointed an official war artist.
So too, on both counts, was Sir John Lavery
(1856–1941), whose paintings of King Edward
VII and Queen Alexandra also hang in the
Saloon. Ruling the roost over the mantelpiece
is a portrait by Sir Arthur Stockdale Cope
(1857–1940) of Electress Sophia of Hanover,
grandmother of George III and the lynchpin
between the Houses of Hanover and Windsor.

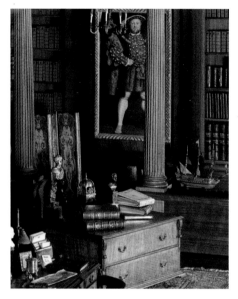

THE LIBRARY

The King's Library too is watched over by
royal eyes: Henry VII was (rather surprisingly)
painted by Frank Reynolds (1876–1953), the
cartoonist and art editor of *Punch* magazine;
Henry VIII is again by Sir Arthur Cope
(Cope was one of Queen Mary's favourite
portraitists); while over the fireplace is Queen
Elizabeth I by William Nicholson.

With its handsome walnut pillars and
panelling, the Library is a room given royal
gravitas by its assembly of red and green
leather dispatch boxes, each embossed with
the royal cipher and 'THE KING'. King
George V would work late into the night
on his boxes, always in the company of
Charlotte, his African grey parrot, to whom
he was devoted. He kept her perched
on his finger by the hour and
encouraged her to forage for
food on the dining-room table.
According to the actress Nancy
Price (1880–1970), when the
King was working the parrot
'viewed state and confidential
documents with a critical

eye from her favourite perch on the King's shoulder and sometimes, when feeling that matters demanded active intervention, she would call out in a strident seafaring voice, "What about it?"'

This room is filled with what was reputed to be a selection of all that was best in the literature of the country at that moment, and has the type of treasures that would have been close to the King's heart. (He had never shared Queen Mary's passion for collecting, other than accumulating snuff boxes and stamps.) Here, the brass Shire horse was modelled on a real-life counterpart, Field Marshal V, from the Sandringham Stud. This 1-inch (3-cm) high replica was sculpted by the French American Herbert Haseltine (1877–1962), whose giant equine statues can be seen as far afield as Jamnagar in India and Arlington National Cemetery in the United States.

The choice of ship to be modelled in miniature was a curious one: a re-creation of the *Royal George* of 1788, which met with disaster off Spithead in 1782 while being loaded with stores. She listed over with a loss of 900 lives, including those of Admiral Kempenfelt and many women and children. William Cowper (1731–1800) penned the commemorative poem.

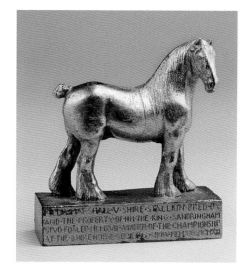

LEFT: Brass model of the Shire horse, Field Marshal V by Herbert Haseltine.

BELOW: The three-masted ship, *Royal George*, was made by the renowned Northampton-based firm of model-makers, Twining Models.

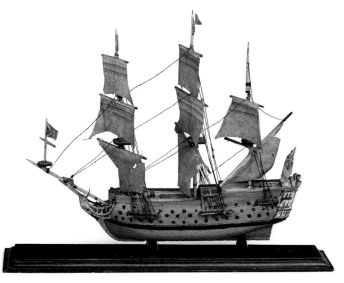

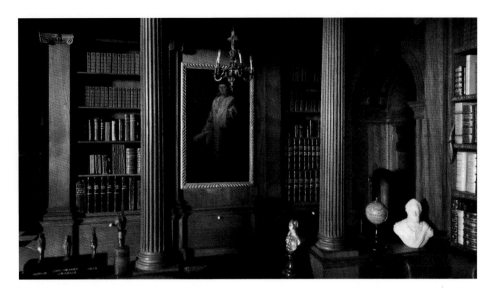

ON THE LOSS OF THE ROYAL GEORGE.
WRITTEN WHEN THE NEWS ARRIVED.
TOLL for the brave!
The brave that are no more;
All sunk beneath the wave,
Fast by their native shore!
Weigh the vessel up,
Once dreaded by our foes!
And mingle with our cup
The tear that England owes.
Her timbers yet are sound,
And she may float again,
Full charged with England's thunder,
And plough the distant main.

The American architectural supremo Frank Lloyd Wright (1867–1959) wrote that he could not think of anyone more capable than Lutyens of 'so characteristically and quietly dramatis[ing] the old English feeling for dignity and comfort in an interior, however or wherever that interior may be in England'. Little matter if the rooms are only inches high, for such is the felicitous feeling in the Dolls' House. 'All is English-made and in the best English taste', reported *The Times* in 1923, while in 1924 Lord Curzon (1859–1925) declared that, if only he had not entered the somewhat depressing profession to which he had dedicated a large portion of his life, he would be a practising architect, building the Queen's Dolls' House for himself to live in. 'Such a house would never be built again', he lamented; 'those who wanted beauty could not afford it, while those who could, desired merely luxury and comfort'.

CHAPTER FOUR

FAMILY LIFE

*For the antiquary of 2123 the literary evidence of our
current life will be overwhelming in bulk. Staggering
amidst the bookstacks in the British Museum ... he will
be unable to see the wood for the trees. But a visit to the
Queen's Dolls' House at Windsor Castle will clarify
all his confusions. There, and only there, will be seen
the unchanged facts of a life of dignified simplicity in
the early part of the twentieth century. Just so and not
otherwise could a King and Queen live and move and
have their being in a home – for it is essentially a home
rather than a palace – made for them by the artists of
their day.*

Sir Lawrence Weaver
The Book of the Queen's Dolls' House, 1924

OPPOSITE: The Nursery, with
its toy train, miniature theatre
and fantastical murals.

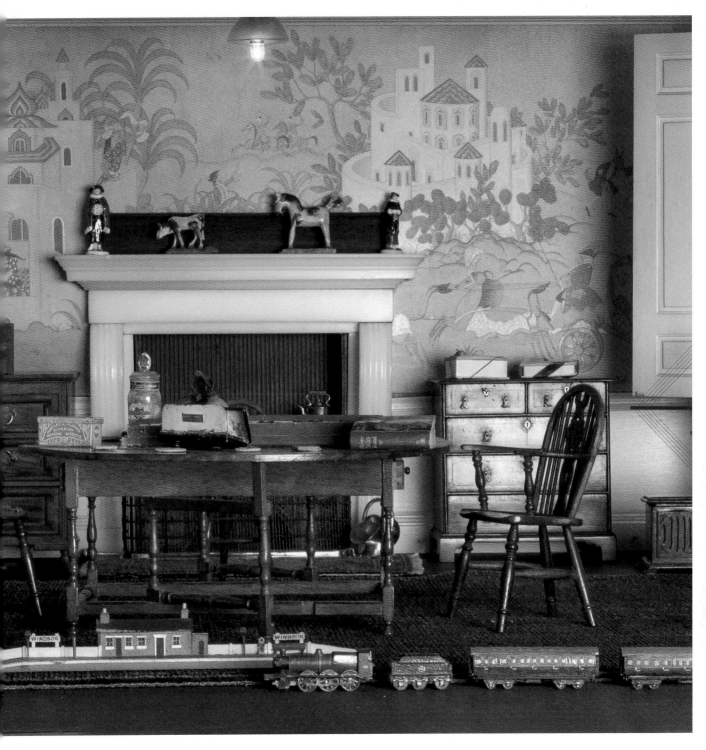

With the Dolls' House on show in the British Empire Exhibition, it was suddenly possible for the public to see how family life was led within a royal household. Here were intimate aspects of royal life that few had dreamt of being privy to: how the Queen's bedtime reading was *The English Bijou Almanac*, that she had a well-used silver box of watercolours on hand in her bedroom and that she kept pink 'bedroom shoes' in her wardrobe. It could be observed that the King's bed was warmed by a copper warming pan, and that the chamber pot beneath his bed was painted with an all-seeing blue eye. It was even revealed that his miniature ivory toothbrush had bristles made from hair from inside the ear of a goat, and that the baby Prince of Wales had a bath of solid silver.

The brass door handles and door locks are now spookily scratched – by whose hands?

LEFT: A tin of Allenburys' Rusks and feeding bottle in the Nursery, here shown at actual size.

BELOW: A miniature ceramic tabby cat with bristle whiskers on a chair in the kitchen.

The miniature reduced palatial magnificence to a scale that the public could relate to. Whereas in a real palace they would have felt lost and overawed, with the Dolls' House, to their delight, they could feel safely at home. A dolls' house is by definition a toy appealing to our most fundamental instincts of shelter and the family. As Christopher Hussey (1899–1970) wrote in *Heavenly Mansions*: 'The "little house" is a phrase that goes straight to the heart, whereas the "big house" is reserved for the prison and the public assistance institutions.' So it was that this little building and, most particularly, the family aspects of the royal life it represented, were to capture the nation's heart.

Yet in truth, there has never been a family as such in the Queen's Dolls' House, thanks to the wise decision never to allow a doll through its doors. This was made in 1921 by 'The Committee of the A.B.C.D.E.F.G.H.I.J.K.L.M. N.O.P. of the Queen's Royal Dolls' House:

Despite the innovatively luxurious bathrooms, both the King and Queen still had a nearer-to-hand chamber pot under their beds (and a warming pan inside). Here, once again, time has stood still: superlative furniture of all eras, set down on wall-to-wall beige carpet: this was how beauty and comfort were enjoyed in the 1920s.

the Architects, Builders, Carpenters, Drain-inspectors, Electricians, Furniture-makers, Goldsmiths, Haberdashers, Image makers, Joiners, Kipper-curers, Librarians, Muffinmen, Numismatists, Opticians and Plumbers', as the writer E.F. Benson described the company of men and women – scholars, academics, historians, writers and experts – who were in charge of the development of the little house.

One of the most marvellous aspects of the Queen's Dolls' House is that, in its exquisite perfection, the miniature has become magical – as if a real and beautiful house with all its contents, by some wizardry, has been reduced to tiny proportions. Furthermore, of course, by reversing the spell it could become a real house once again. Hence the banishment of dolls, since one plonked into the midst of this

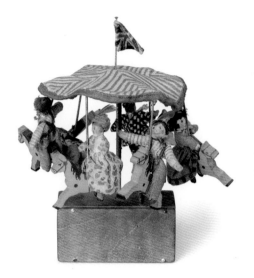

Toy merry-go-round crowned with a red and white striped cotton canopy, under which whirl joyous riders on their wooden painted horses. The wooden base contains a mechanism and a turning handle.

magic would have grotesquely dispelled that enchantment. E.F. Benson's description (in *The Book of the Queen's Dolls' House*) of the Committee's reasoning cannot be bettered:

A Doll is not a human being in miniature at all, it never produced the slightest illusion of being a real person made magically small, and anyone can easily imagine what a monstrous deformity a Doll would be if it was magically restored to human size ... You can look at the pictures, and see what they are meant for, you can read the books, and understand more or less, what they are about ... you could ... go to bed with great comfort in that bed. But Dolls could have done none of those things: they might have fixed their glassy eyes on the pictures, but they would never

have seen them ... and if they had ever got into bed at all, they would probably have been placed there with all their clothes on, because of their revolting appearance when undressed ... Dolls, in fact, in the Dolls' House would have been the most gross of solecisms.

There are therefore no spirits of former occupants to haunt the Dolls' House, save for the ghost bequeathed it by Vita Sackville-West (1892–1962) in *A Note of Explanation*, which she wrote for its Library. Instead, the little house is richly peopled by the spirits of those who created it, along with those of the family for whom it was created.

So passionately did Lutyens plunge into every stage of the house's progress that he grew to think of it as his home – as indeed would anyone whose face had been thrust into these little rooms for some three years. Queen Mary also thought of it as 'My house'; in 1921 Lutyens wrote to his wife that the Queen was 'nervous as to how the Dolls' House opens ... she wants to be able to open it without calling servants! ... Can you see the Queen going hush hush to play?' She and the King once asked to be alone to play with it for four hours, and Queen Mary often rearranged the furniture.

THE NURSERY

Lutyens had given no less thought to the design of the Nursery than he had to the State Dining Room, just as he had taken as much trouble with the Queen's Boudoir and its jade- and amber-filled glass cabinets – exact copies of those in which Queen Mary displayed her *objets d'art* – as he did with the grand Saloon.

As with a real house, where you can sense the happiness of the home, so it is that you can feel the Dolls' House's palpably cheery atmosphere, most especially where family life reigns supreme. Nowhere, of course, is this more apparent than in the Nursery, chock-a-block with toys, with a jar of barley sugar sticks and a tin of Allenburys' Rusks,

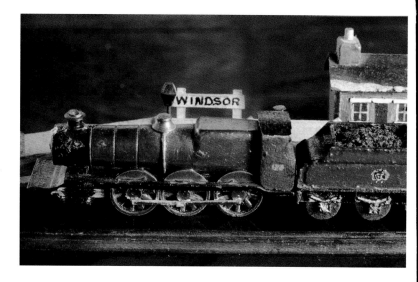

The tiny Bassett-Lowke steam train – procured by Lutyens through a correspondence with Mr Bassett-Lowke himself, who wrote on his company's exquisite Art Deco notepaper – that draws up at the toy Windsor Station is 10 cm long, the hobby horse only 6.3 cm.

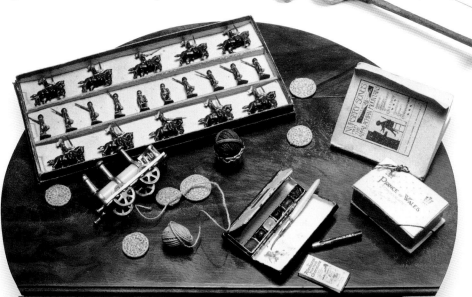

Assortment of miniature toys, including a box of tin soldiers.

A child's nightgown, laid out on one of the beds in the Nursery.

with *Father Tuck's Annual* as well as a box of tin soldiers 'so tiny that a ladybird could push them', according to the official account of the Nursery by Lady Cynthia Asquith (1887–1960).

Most baffling of all here is what was described in the official book as 'The odd Night-gown demonstrating the Fitting of the Garments'. Most haunting are the children's padded wool-lined gauze pneumonia jackets,

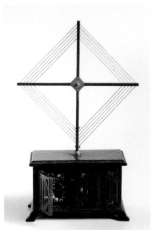

ABOVE: In tandem with the times the Nursery has a 'Wireless Cabinet Receiver'. Such models were invented by the British Thomson-Houston Company and only introduced in 1920.

Nursery Songs of the Appalachian Mountains, arranged by the collector of folk songs Cecil J. Sharp, waits to be played on the upright piano.

worn to keep in the body heat if they were struck by the potentially fatal disease – only four years before scientist Sir Alexander Fleming (1881–1955) would discover the benefits of penicillin.

This little room will be forever embraced by the chinoiserie murals of fairy stories by Edmund Dulac (1882–1953), the French star of Britain's Golden Age of illustration, from the 1880s to the 1920s. As with everything that Dulac did, here his imagination has whipped up strange and exciting scenes. In one, a Georgian Cinderella in an eighteenth-century coach driven by a periwigged coachman, gallops through a cacti-filled desert, whilst on the horizon a wolf in breeches pats Red Riding Hood on the head. Nearby, palm trees surround Bluebeard's domed pink palace, in which the villain sits sharpening a scimitar to kill his latest wife. A frightening green genie, the same size as the would-be children in this Nursery, is being rubbed into being by Aladdin; Sinbad, in a ship with a prow shaped

like a peacock, hails Robinson Crusoe and Man Friday, who wave from on high on a steep cacti-sprouting cliff. 'There are magic happenings on these walls', wrote William Newton of the *Architectural Review.*

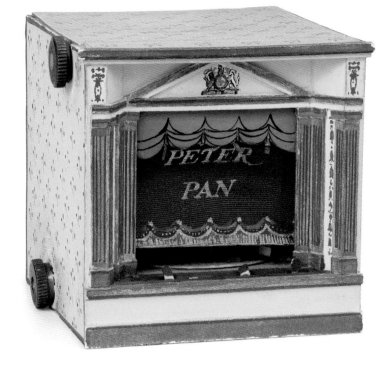

ABOVE: As for the tiny electrically lit theatre, with Peter Pan painted on the safety curtain and two stage sets from the play, this is an enchanting celebration of Lutyens's long friendship with the author J.M. Barrie. In 1904 Lutyens had designed the set of the night nursery for the very first production of *Peter Pan or The Boy Who Wouldn't Grow Up.* He would later tell his children that the story had taken place in their bedroom in Bloomsbury Square, and that Peter Pan himself might appear at any moment to spirit them away.

LEFT: An elegantly carved wooden cabinet is revealed to contain a wind-up gramophone, made in various stages by some 70 craftspeople from the Gramophone Co. Ltd. It is only 5½ inches (14 cm) high and, it works! Complete with records such as *Rule Britannia, Home Sweet Home* and *God Save The King,* it was nevertheless banished to the Nursery. Despite Lutyens having decreed that it be designed in a grand walnut case, to enable it to grace any room in the house, it was not to be: Queen Mary wrote to Princess Marie Louise that 'the gramophone should go in the nursery as G. [King George] hates them!'

THE QUEEN'S BOUDOIR

Dulac, one of the most wildly romantic of all fairy-tale illustrators, has a popularity that still shows no signs of abating. The Dolls' House Nursery contains his only murals, life-size or otherwise, although he also painted the ochre-coloured silk on the walls of the Queen's miniature Boudoir. Again in the Chinese style, with waterlilies and swirling clouds, they are happily in harmony with the Asian-inspired furniture of both bamboo and yellow lacquer that was given by Lord Waring, of the furniture manufacturers Waring & Gillow.

The Chinese carpet in the Queen's Boudoir is a tiny copy, with 324 knots to an inch, of a rug of the Qianlong period (1736–95).

The Princess Royal's Bedroom contains a miniature copy of Lutyens's own bed. Lutyens died in his 'St Ursula' bed in 1944. 'There is nothing the dead look like except dead', wrote his daughter Mary. 'Father's familiar suits with their bulging pockets hanging in the cupboards had far more of him in them than the empty body in the St Ursula bed.'

THE PRINCESS ROYAL'S BEDROOM

Cosily ensconced in family life, the Queen's Boudoir is between the Night Nursery and the Princess Royal's Bedroom, with its mahogany and cane four-poster bed. This is a 7-inch (18-cm) high version of one of a pair that Lutyens had designed for his daughters Barbie and Ursula; they are known as the 'St Ursula' beds, having been inspired by the four-poster in Vittore Carpaccio's painting *The Dream of St Ursula* (1495) in the Accademia in Venice. (Lutyens also named his youngest daughter after the painting.) Most suitably for the Princess Royal, when the Dolls' House version was made, a baby pea was put beneath the mattress. Now no more, the pea is one of the House's few casualties, wrought by the ravages of time.

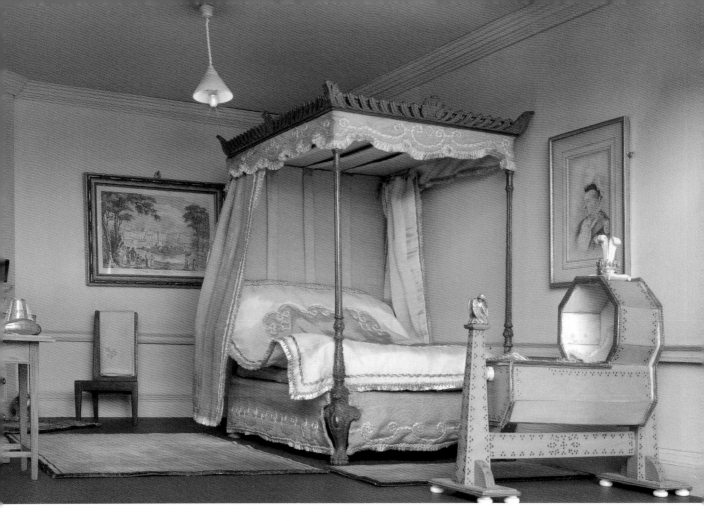

THE NIGHT NURSERY

The Night Nursery has what is arguably one of the most entrancing pieces of furniture in the Dolls' House. This is 'the cradle for the Prince of the Blood', as Lutyens called it, made of applewood, ivory and silver. With its hood and body faceted like a 20p piece, all edged and inlaid with silver, it swings between obelisks on ivory-handled spindles. A silver angel kneels towards the baby from atop one obelisk; while on the hood, an ivory cushion bears the weight of a silver crown sprouting ivory Prince of Wales's feathers.

For the baby prince's nanny, who slept with her charge, the grandeur of her mahogany four-poster bed with its elaborately carved cornice proudly proclaimed her place in the hierarchy of the household. The Lutyens

family's beloved nanny, Alice Louise Sleath, was with the family for thirty-nine years, every one of which was celebrated with what Lutyens called a 'nannieversary'. When she died, Lutyens designed her headstone with five angels – his five children whom she had helped to raise. This family devotion must have contributed to the splendid furniture with which he honoured the Dolls' House nanny.

THE BATHROOMS

The most lustrously shining of all the rooms in the Dolls' House are the two royal bathrooms, with their sleek walls of marble, ivory or snakeskin, all hung with pictures. Their painted ceilings are top-notch beauties, as are their floors of marble and mother of pearl. Both baths are curvaceously Lutyenesque; these same forms can be found full-size in houses designed by Lutyens throughout the country. The King's tub was hewn from green African verdite, a richly coloured ornamental stone that is no longer allowed to be exported; the Queen's from translucent alabaster, set down in a room where mother of pearl shimmers across the floor and where a white ivory dado and columns set off the green sharkskin walls to perfection. A round of applause, please!

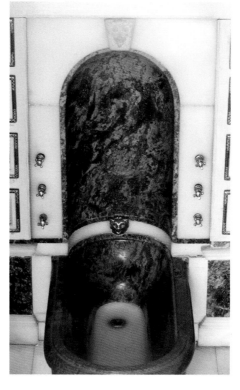

LEFT: The King's Bath made from African Verdite.

OPPOSITE: The King's Bathroom.

In *Everybody's Book of The Queen's Dolls' House*, Percy Macquoid wrote a paean of praise to this room:

It is one of the prettiest sights in the world to see the bath-tub filled with water, to see the drops swelling slowly from the taps until the whole room is reflected in them, filled with indescribable, minute beauty; and the reflection of the mother of pearl and of the paintings on the ceiling, give added colour to the natural iridescence of these globes of water.

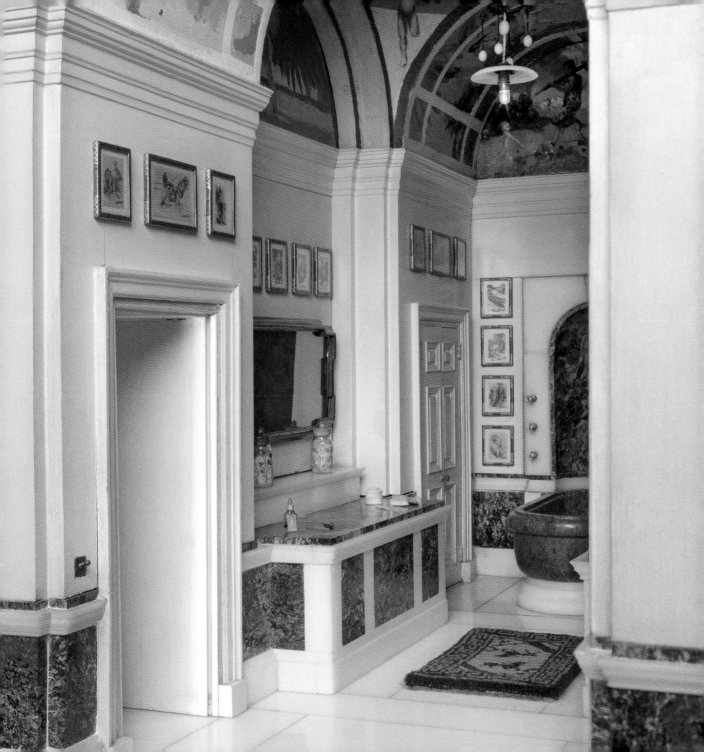

A tiny glimpse into history in these two rooms is found in the sponges donated by Sir Jesse Boot (1850–1931), founder of Boots the Chemist. Almost unseen in an alcove is the Queen's water closet, elegantly disguised as an eighteenth-century wooden armchair and painted gold with cane panels. The King's W.C., more masculine in its plain wooden cabinet, is a 'Valve Closet', with a handle at your side to pull up for the flush. Both water closets were made by the grand old nineteenth-century firm of John Bolding & Sons, one of the heroic band of inventors and engineers as well as producers and manufacturers (not forgetting politicians) who had to fight through the clogged inertia of sanitary reform. In 1966 Bolding took over the most famed of them all, Thomas Crapper & Co. The mastery of such plumbing in miniature was a marvel to behold and Queen Mary was forever captivated by the cleverness of all the Dolls' House mechanics. Once, when the proud-as-punch engineer was showing her the lifts and the lavatories, she got her earring caught in his beard.

The disguised water closet in the Queen's Bedroom.

GAMES AND SPORT

Royal and grandee family life more often than not meant a sporting life and in the Dolls' House a games cupboard bulges forth with all the impedimenta of golf, tennis and cricket. The Queen was particularly fond of croquet and a complete set stands by; while for the sportsman-King, two miraculously made 3-inch (10-cm) long Purdey guns are ready and able to kill a fly. A cupboard was made for them in the Library, but King George V, renowned as a great shot, was so delighted with their workmanship that he insisted they be laid out to be admired. They are exact replicas of the guns he used and, as with so many treasures in the Dolls' House, you gasp at the dexterity that made them. With what must surely be the smallest double gun barrels in the world, they have smooth wooden stocks and half pistol grips; a top lever and two triggers. Furthermore, believe it or not, they can actually break, load and fire. There is also a little leather cartridge bag, as well as a magazine of a hundred tiny cartridges, the gunpowder for which came from Nobel's Explosives Co. Ltd. The King was also provided with an umbrella and handsome walking sticks, all made by Brigg, 'Royal Umbrella Maker' since 1836, which,

ABOVE: As part and parcel of the little arsenal, Purdey presented a shooting stick made of wood, including the seat, which hinges up to become a handle. Called the 'King's Pattern', it was emblazoned with a graceful cipher and crown of brass.

RIGHT: Made by James Purdey & Sons – royal gun-makers since supplying Queen Victoria with two pistols in 1838 – these guns were donated by Athol Purdey, the founder's grandson. They were presented to the Dolls' House in a leather case complete with cleaning rod, tow and oil.

now amalgamated with Swaine, continues to
flourish today.

All the other sporting fronts were also
right royally indulged, including archery with
targets, bows and arrows, and fencing with
two foils, glove and mask. More sedentary
games too; most notably with the Library
chess set on its tiny 'Chippendale' table (an
exact copy of one in the Victoria and Albert
Museum) made in eighty-two separate pieces,

Nothing has been forgotten in this royal
residence 'which appears to have been built
by the cleverest human brains in the bodies
of ants', as reported by *The Times* on 29 July
1924; while A.C. Benson delighted in it having

The chessmen, all made of ivory
without a join – the king, at less
than half an inch (12 mm) high, is
the tallest – are modelled on the
Staunton set, named after Harold
Staunton, who in 1849 designed
the first universally recognised
model for chess pieces.

The Dolls' House golf set laid against a life-size ball. Wooden golf clubs (as well as irons) have their own 6.5 cm long leather bag embossed in gold with the royal cipher. These were supplied by Ben Sayers of North Berwick, who had taught golf to Queen Alexandra, the Prince of Wales and also the Duke of York (before he became King George V).

been the combined work of many hands, heads and hearts. 'One of the pleasant things about the Queen's House', he wrote, 'is that it has not been got together by the overwork and anxiety of a few, but by the enjoyable and willing co-operation of many delighted designers, craftsmen and donors.' And all this was jubilantly co-ordinated by Master of Ceremonies Edwin Lutyens. 'His genius was fairy-like, as if he had touched the houses with a wand', wrote his friend Lady Sackville, although she worried that he was embracing work on the Dolls' House almost to the exclusion of all else. That such a distinguished architect should have flung himself so wholeheartedly and with such

happy seriousness into this little building – days that he called his 'vivreations', the word he coined for fun – shows the measure of the man.

In 1924, the year that the Dolls' House was finished, the youthful architectural historian John Summerson (1904–92) published a sequel to *Gulliver's Travels*. Called *The Queen's Dolls' House: The Palace of their Majesties the King and Queen of Lilliput*, it tells the tale of Gulliver, returning to Lilliput and finding that Lutyens has built a dolls' house as the new Imperial palace for the King and Queen of the Lilliputians. Entranced, the giant Gulliver peers through the windows:

... upon the rich spectacle within ... the Court ladies and gentlemen... with their dainty young, decked out in their finest of silks and satins, and feathers in their hair like an ostrich's but smaller than the down of a sparrow ... When I held my breath I could hear Music, played by a company of musicians gathered upon the marble stairs. It was very high-pitched, like the singing of grasshoppers in summer, yet melodious and measured ...

So a royal family life has been lived in the Dolls' House after all. Gulliver's only regret was that, owing to his unfortunate size, he was unable to get inside it. So say all of us.

CHAPTER FIVE

THE LIBRARY &
ART COLLECTION

*How many London residences, even in Berkeley Square
and Park Lane, have a library consisting of two hundred
books written in their authors' own hands, and a
collection of over seven hundred watercolours by living
artists? I doubt even if you could find the counterpart of
these in the real Buckingham Palace.*

E.V. Lucas
The Book of the Queen's Dolls' House, 1924

*... do you not think I ought perhaps to accept drawings
from poorer and humbler people, otherwise they may
think the dolls' house is too aristocratic ...*

Queen Mary, in a letter to
Princess Marie Louise, 28 October 1922

OPPOSITE: The King's Library,
overlooked by the imposing portrait
of Henry VIII by Sir Arthur Stockdale
Cope (1857–1940).

Anyone who sees the books will appreciate that it was, even physically, quite a difficult task; it is by no means easy to write neatly in a fat little volume about the size of two postage stamps; but it was a labour of love to all, and the outcome of this labour will remain forever a miniature picture of English literature in the nineteen-twenties.

Stephen Gaselee
The Book of the Queen's Dolls' House, 1924

The bindings alone of the hundreds of tiny books in the Dolls' House Library are like jewels – their richly coloured leather glinting with gilded decoration – let alone the incalculable importance of their contents. What value can possibly be given to a $1\frac{1}{2} \times 1$ inch (4×3 cm) book of poems by Rudyard Kipling (1865–1936), with over 60 pages handwritten by him in a flowing script, or otherwise in neat-as-pins capital letters? There are also several pages of his unique minuscule drawings.

For the poem 'Eddi's Service', the Saxon tale of the priest preaching to a bullock and a donkey as the only members of his congregation, Kipling entwined Celtic forms

C. Spencelayh, R.M.S.

ABOVE: Charles Spencelayh painted a marvellously detailed face of an old man, pondering a depiction of King George V on a large canvas in his hands. He was a favourite of Queen Mary and this was his way of painting a portrait of the King.

TOP: A Birthday Book by Lady Katherine Lloyd of Bronwydd.

around his verse; while for 'A Charm' he drew
grim trees and gravestones:

> *Take of English earth as much*
> *As either hand can rightly clutch*
> *In the taking of it breathe*
> *Prayer for all who lie beneath …*

The Dolls' House Library was to be 'a
representative, rather than a complete
library', according to Princess Marie Louise,
the self-appointed librarian who, with her
literary friend E.V. Lucas, was responsible
for its organisation. In flamboyant writing –
almost as enticing as honouring the request
itself – she sent personal pleas to over 170

authors and more than 640 artists, including
cartoonists, asking them for donations of
books, watercolours, drawings, sketches,
etchings, linocuts or engravings; 25 composers
were asked for musical scores. To the artists
she gave the dimensions of what their pictures
should be to fit into the Library's two wooden
folio cabinets; to the writers, she sent tiny
blank volumes for them to fill. Once safely
returned, they would be bound in leather of
every hue, which would then be enriched with
an array of tooled and embossed decoration.

Lucas, too, was responsible for roping in
many of the artists and authors, writing long
and detailed requests in draft for Princess
Marie Louise to then send to such luminaries
as Bridges, A.E. Housman and Rose Macaulay.
In his letter to the orientalist and linguist
Sir Denison Ross (1871–1940), he asked if there
were any dolls in East Asia, and proposed as
'a suggestion … not as … a direction' that if

so, 'might not the English dolls like to know about this?' To the critic Desmond MacCarthy (1877–1952) – whose fellow 'Bloomsbury Group' member Virginia Woolf was one of the few writers who refused the Dolls' House commission – he wrote 'I venture to suggest that a little manual on English literature or reading for the dolls would be very acceptable'. In a letter to C.H. Collins Baker (1880–1959), Keeper of the National Gallery, he proposed 'a little manual on the best pictures for dolls', while to the scholar John Williamson Mackail (1859–1945), grandson of Edward Burne-Jones, he hinted that 'something in Latin would be especially attractive'. George Bernard Shaw was another author – as was John Masefield – who refused to contribute to the Dolls' House Library; 'and I am going to say quite plainly that he wrote in a very rude manner', lamented Princess Marie Louise in her *My Memories of Six Reigns* (1956). 'His letter was not even amusing and, at the risk of offending his many admirers, I say that it was not worthy of one who claimed, as he did, to be a man of genius. I fail to see how he could have missed this great opportunity to have one of his works included in the Dolls' House as a record of an outstanding author in the reign of George V.'

No doubt the idea of his book luxuriating amid the splendours of this royal library – albeit in the company of works by friends such as G.K. Chesterton – would not have been relished by as fiery a socialist polemicist as ever lived. His fame, however, ensured his immortalisation on these shelves: he is satirised in 'Little Fables' by the actor, dramatist and stage director Sir Arthur Pinero (1855–1934), and Chesterton wrote a pretend critique by Shaw of the poem he donated to the Dolls' House. Called 'The Ballad of Three Horns', it tells of Robin Hood slaying 'The Black Bull of the North / That has trampled spears like grass'. Chesterton's view of Shaw, with his ardent vegetarian views, was straightaway up to his usual tricks, retorting that 'Had the bull not been a decent self-

4.5 cm

Poems: Abridged for Dolls and Princes by Robert Bridges (1844–1930), the Poet Laureate of the day.

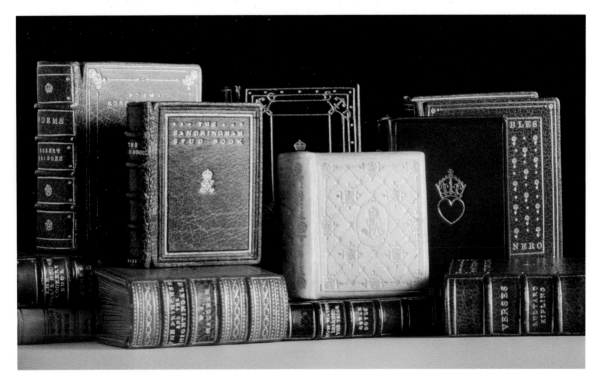

A selection of miniature volumes.

respecting Vegetarian, he could have made a mouthful of Robin Hood'. The poem has fifty-four verses, and it is scarcely believable but Chesterton penned every word of them in his diminutive book. Each verse is four lines long, with one to a page and topped and tailed with a flourish; and Chesterton inscribed them in writing, strange to say, that did not have to be reduced from his everyday tiny hand. How pleasing to think of this immense genius, 6ft 4ins tall and, by 1922, well on his way to weighing 133 kilograms, applying himself to the tiny task. He delayed its delivery 'due to some vague hope', he wrote to Princess Marie Louise, 'of doing something … worthy of so national and historic an object'.

The lettered illuminati responded in their eager droves, many of them returning their completed books within a few days. They were flattered, overwhelmed and proud. M.R. James (1862–1936) was 'much honoured' and hoped that *The Haunted Dolls' House* was 'generally suitable' (it most marvellously is). Edmund Gosse (1849–1928) wrote of his gratification at adding to 'the fairy mansion which will be of so much lasting interest'; Edith Wharton

(1862–1937) sent what she described as 'doggerel ... unworthy of so charming a destination'. She was right; her poem 'Elves' Library' is appalling. Aldous Huxley (1894–1963) hastily dispatched unpublished poems by return of post; A.E. Housman (1859–1936) applied himself with 'delightful readiness', sending poems including verses from his famed *Shropshire Lad* (1896); while the offering from Compton Mackenzie (1883–1972) struck a singular note with extracts from *Sinister Street* of 1914, made unique for the Dolls' House by his putting back all the non-fictional names of the story. Robert Bridges (1844–1930), the Poet Laureate of the day, then approaching eighty, pleaded that 'neither my hands or eyes are young enough to do such miniature work creditably', but he eventually sent reams of verses, copied out by both him and Mrs Bridges 'in a more careful script'.

John Buchan (1875–1940), writing that it was a very great pleasure to have a share in the miniature library, contributed his stirring *Battle of the Somme*. All these books were assembled only four years after the end of the First World War and its shadow was bound to hang heavy over this collection: most moving of the lot is William J. Locke's (1863–1930) *Miles Ignotus: A Little Tale of the Great War*

SIR JOHN BLAND-SUTTON BART.

Some surgeons cut you up like mutton,
But that is not the way with SUTTON;
Bland is his name, though stern of eye,
He couldn't bear to hurt a fly.

MR. PUNCH'S PERSONALITIES.—VIII.

especially written for the Library of Her Majesty's Model Palace. Edmund Blunden (1896–1974), the longest serving of all the War poets – on the front from 1916 to 1918 – sent four of his works, including 'Behind the Line'. His friend Siegfried Sassoon (1886–1967), who wrote that Blunden was the poet of the War most lastingly obsessed by it, is another to haunt these shelves with 'Everyone Sang'. As for Sir Philip Gibbs (1877–1962), one of the most prolific of all War correspondents; his contribution of *The Unknown Warrior* moves you to the very core.

There are conspicuous literary omissions; most particularly the works of T.S. Eliot. *The Waste Land* was published in 1922, the year

Out on a limb is the *Principles of Doll-Surgery* by Sir John Bland-Sutton, pre-eminent surgeon of his day. Thanking Princess Marie Louise for the tiny blank notebook she had sent, he wrote that his little monograph on doll surgery would be a source of amusement and pleasure. His advice was far from dainty, with such recommendations as what to do when a doll's eye is damaged: 'The roof of the skull is cut off with a sharp knife, as the head of a doll does not possess a brain' and so on, all with finely wrought diagrams.

the library was assembled, but was evidently not thought suitable for royal perusal. (To add insult to injury, the Library has a painting by his father-in-law, Charles Haigh-Wood.)

It is with the Library that you are most disturbed by the lottery of fame, for so many of the authors who were then best-sellers are little known to us today. One of these, Maurice Baring (1874–1945), produced twenty-nine books between 1905 and 1924. For the Dolls' House, he chose to send his 'Elegy on the Death of Juliet's Owl.' Ethel M. Dell (1881–1939) is another such example: 'The most popular English writer of the present day', according to E.V. Lucas, she published forty books between 1912 and 1949. Worshipped by her readers and despised by her critics, she was scorned and burlesqued by both George Orwell and P.G. Wodehouse. Now she is almost entirely forgotten.

There are those, too, who are remembered thanks to a single book: Anthony Hope (1863–1933) has been assured immortality with his *Prisoner of Zenda* (1894) and in the Dolls' House, *A Tragedy In Outline* charts the rise and fall of a romance in a correspondence of ten letters. Again, strange to say, Hope's ordinary writing was exactly the same size as that in this minuscule volume.

From the 71 books published by Harry Graham (1874–1936), only *Ruthless Rhymes* (1898) has stood the test of time. Likewise, Hilaire Belloc is chiefly remembered for his *Cautionary Tales for Children* (1907), oddly not submitted for the Library. He sent 'Peter and Paul: A Moral Tale', preceded by an excited acceptance telegram to Princess Marie Louise, 'to avoid delay'. Sir Henry Newbolt (1862–1938) is another who will be forever remembered, thanks to the legendary lines 'Play up! Play up! and play the game!' from his *Vita Lampada* of 1897. Of the poems Newbolt chose for this Library, 'Drake's Drum' is still well-known. 'Vespers' was donated by A.A. Milne (1882–1956), who will be remembered for all time thanks to Winnie the Pooh; whilst Ernest Shepard, the illustrator of *Winnie the Pooh* (1926), designed the bookplates for the Dolls' House Library: these show *MR* ('Mary Regina') entwined above a black silhouette of Windsor Castle with the flag at full mast.

And there are many more stars. Thomas Hardy contributed nine poems and Robert Graves sent five. Sir Arthur Conan Doyle (1859–1930) created a Sherlock Holmes story, *How Watson Learned the Trick*, especially for the Dolls' House, again in writing barely altered in size from his everyday hand

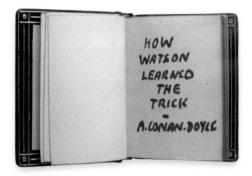

How Watson Learned the Trick by Sir Arthur Conan Doyle.

although in a very thick black pen; while Max Beerbohm, too, wrote specifically for this Library, with the *Meditations of a Refugee*. His hero has always yearned to be very small: 'I approached Mr W.B. Yeats. He looked down at me and said that I seemed quite small enough already' Eventually, by sheer willpower, he succeeds in becoming tiny. 'When I heard … that Edwin Lutyens had built for the Queen "a one inch scale model of a twentieth-century mansion"… I came straight to Buckingham Palace … I found the mansion. I have been all over it. Lutyens has never done anything better…I shall abide here always.'

Taking the prize for lustrous good fun combined with opulent architectural descriptions is the tale of *The House of The Marquis of Carabas* by the architect Sir Reginald Blomfield (1856–1942). But for yelling-out-loud laughter, no miniature book is funnier than the tongue-in-cheek *More Memories of the Future: Being Memoirs of the Years 1915–1972 by Opal, Lady Porslock*, by Father Ronald Knox (1888–1957). Its narrator is supposedly looking back to 1960s' London, and reminiscing about the creation of a gigantic room, ten times larger than life-size.

The Library's greatest *tour de force* is in fact by a cartoonist, or rather one of *the* cartoonists of the day: 'Fougasse', whose real name was Cyril Kenneth Bird (1887–1965). Popular during the First World War, his influence during the Second World War would penetrate into every mind in the land. The propaganda campaign 'Careless Talk Costs Lives' (showing such scenes as Hitler and

Fougasse's illustrations for 'J. Smith'.

Goering sitting on the bus behind yakking women) meant his instantly recognisable angular drawings were absorbed into the national imagination. When some years after the First World War, patriotic duty called for a contribution to the Queen's Dolls' House, Fougasse excelled, applying what seems impossible dexterity to 64 verses, along with many many more illustrations, telling the story of 'J. Smith'; all written, drawn and painted with a period charm that swirls you back to 1922:

> *One night in mid-September,*
> *While storm-clouds rode the air,*
> *And a tempest swayed the tree tops*
> *Stripping the branches bare,*
> *A fairy was blown out of fairyland,*
> *And fell in Eaton Square.*

Printed books too play an important part here, as with the heart-quickeningly evocative *Bradshaw's Railway Guide*. There are two Bibles and two Qur'ans, while Shakespeare of course has his head held high. With *The Complete Works* in 40 volumes, each measuring $2 \times 1\frac{1}{2}$ inches (5×3.8 cm), and bound in red leather with gilt edges, this is the 'Ellen Terry' Bijou Edition.

Not to be left out are the four little books of signatures of the most eminent individuals across various fields: *The Stage*, with autographs of the greatest actors and actresses – the one by Ellen Terry (1847–1928) twirls across one page; then there are the most renowned politicians and officers, who signed their way into the history of the Dolls' House in its tiny volumes of *The Statesmen*, *The Army* and *The Navy*. Also typical of the miscellaneous masterpieces is *The Sandringham Stud Book*, lauded in its day as having been scrupulously compiled by Major F. Fetherstonhaugh.

The beauty of the bindings is largely thanks to the firm of Sangorski & Sutcliffe. George Sutcliffe was delighted to take on the work, writing to Princess Marie Louise in 1922 that 'It will be a pleasurable holiday recreation from our hum-drum work and do not hesitate to send me all you desire to have done though at the same time I would not wish to deprive any of my colleagues of the joy of sharing with me the binding of one of the most wonderful libraries in the world. Mr Kipling's manuscript is really priceless.' C.W. Whitaker was concerned about *Whitaker's Almanac*, lamenting that 'There are certain technical difficulties in the reproduction in miniature of such a voluminous work.' Lutyens was tickled

pink by the bargain of the books, writing to the Princess that he had got an estimate for the worth of a single volume. 'A "classic" £600!!!!! Dolly luyah! As we may want 1000 bks, it means an expenditure of £600,000 – too wild for words – but as we must get them for nothing think what the value of the Dollhouse will be!'

With the paintings and drawings as with the books, so many of the artists who would originally have read like a roll-call of honour now appear as a roll-call of the unknown. Who today knows the paintings of John William Schofield? It was with difficulty that I ran one to ground in the Valance House Museum in Dagenham. His little watercolour in the Dolls' House, of a shepherd and sheep, however, makes you gasp at his mastery of light: the last rays of the setting sun, the glow from church windows and door and the

Among the many almanacs and dictionaries there is a tiny album of photographs.

moonlight shining silver onto its roof and silhouetting its spire, all of which, remember, are painted in an area measuring $1 \times 1\frac{1}{2}$ inches (2.5 × 3.8 cm)!

These pictures are like little stepping stones through British art since the nineteenth century, leading you from full-blown Victorian sentiment (all the artists were of course born Victorians) on to the Pre-Raphaelites and through the twirls of Art Nouveau. The Impressionists are brilliantly represented by the garden painted by Tom Mostyn (1864–1930), with flowers that glow like fairy lights, and marching forth in crispest Modernism – even Surrealism and Vorticism – *Dymchurch Wall* by Paul Nash (1889–1946), inscribed and signed (as is almost every painting) and dated on the back. So it is with the illustrators; all aspects of their craft have been embraced, with such heroes as Henry Justice Ford (1860–

J.W. Schofield, R.I.

LEFT: John William Schofield's watercolour of a shepherd and his sheep.

Paul Nash's *Dymchurch Wall*.

Paul Nash.

1940), who has bewitched generations of children in Andrew Lang's twelve *Fairy Books* (1889–1910) – the 'Red, Blue, Green', etc. Here his *Winged Female* lies next to the work of the band of designers for London Transport. F. Gregory Brown (1887–1941) was one, and his little painting of a house and tree in brilliant

hues is instantly recognisable from his posters for London Underground.

In total there are over 750 works of art (I maintain that all illustrations fall into that category), watercolours and drawings – in pencil, pen and ink and chalk – etchings, mezzotints, aquatints and engravings, as well as lithographs, a few 'photographic reproductions' and one oil painting (on board) as well as a lone linocut. They appear on paper, ivory or even lambskin. Among the portraits on ivory is the all-important Princess Marie Louise; a harmony of yellows, browns, creams and greens painted by Alfred Praga (1867–1949), President of the Society of Miniaturists. Funnily enough, so great was the dexterity of all the artists that the expert miniaturists have by no means stolen a march on the rest. Dora Webb is an exception, having produced a parade of the finest miniatures. They include the baby Ariel on a bat's back; two very-much-of-the-period naked children with golden curls; a festive 'Trilby' (the heroine of George du Maurier's 1894 novel of the same name) with striped pantaloons; and a startlingly moving portrait of the then Prince of Wales, in white naval uniform, with very pink lips and cheeks and with his blue eyes staring forth – fourteen years before the country was plunged into crisis by his abdication.

BELOW LEFT:
Dora Webb, *The Prince of Wales*.

BELOW RIGHT:
F. Gregory Brown's landscape.

Dora Webb, A.R.M.S.

F. Gregory Brown, R.B.A.

In gazing upon the many vistas of the countryside and villages, you both marvel and are made miserable in one fell swoop. Whilst the spirits are sent soaring by the artists' quite astonishing ability, they are smote down by the countless glimpses – albeit from an often romanticised and idealised point of view – of an England now long gone. For his *The Approach of Night*, the dashingly moustachioed Glaswegian James Hamilton Mackenzie (1875–1926) painted a man ploughing with two horses on the horizon; whilst Lucy Kemp-Welch, the queen of equine painters, produced the evocative *Home from the Fields*, of a boy riding one of three carthorses. Most ravishing of all is a watercolour of a girl galloping side-saddle on the seashore by Heywood Hardy (1843–1933). Horses were painted at the farrier's forge by Frederick Elwell (1870–1958), whose scenes of Beverley life in Yorkshire still have a huge following today. So, too, does the work of Helen Allingham (1848–1926), the first woman to become a full member of the Royal Watercolour Society. Through her watercolours she set out to immortalise the cottages and gardens of Surrey, before they were either modernised or demolished during the 1880s. As for the picturesqueness of hay stukes marching over the landscapes in so many

Heywood Hardy's *Girl Riding Side-Saddle*.

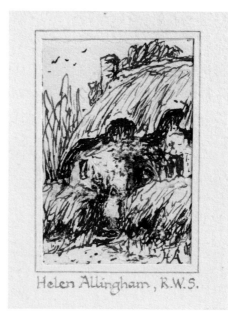

The contribution of Helen Allingham.

Still making you smile is Bonzo the dog, the popular pal created for *The Sketch* by Ernest Studdy in 1921 and named in 1922. Popular enough to appear in the neon lights of Piccadilly Circus, he was translated into six languages, including Czech, as well as appearing in twenty-six films; indeed, the first public film outing for King George V and Queen Mary included Bonzo's *The Sausage Sensation* in the programme. Here he is, still laughing away in their Library.

G. E. Studdy.

Frank Reynolds, R.I.

What, too, of the cartoons, with such extraordinarily wonderful paintings as the huge (relatively speaking) face of Mr Punch with his beady-eyed pug in a ruff, by Frank Reynolds of *Punch* magazine?

of these paintings – woe betide the black plastic rolls of today – how many of us remember little private hay stukes in cottage gardens, as recorded by another brilliant watercolourist, Frank Walton (1840–1928)?

Faces too, as well as places, have been preserved for posterity inside these little cabinets. It 'having been whispered' that Queen Mary wanted 'a little picture of herself in the style of the "Old Master"' that Sir Arthur Cope had produced for the House, Cope 'determined to try and do something and, if it turned out a failure … say nothing about it'. In spite of his injunction to 'say nothing to the Q', to Cope's mock-annoyance the cat was let out of the bag: 'I now gather

that that horrid fellow Lutyens has given away my very small secret, and fled to India so that I cannot murder him – yet!' It all ended well, with the Queen writing to Princess Marie Louise that 'George is delighted with my picture by Cope'.

A great loss to the Dolls' House art collection was that nothing came of Charlie Chaplin's proposal – made in 1921 to Lutyens at the Garrick Club, London – to 'give a tiny portrait of himself by himself'. Chaplin actually went to see the Dolls' House being built in Apple Tree Yard and, according to Lutyens, 'was thrilled with Dolly Luyah'. Another absentee is a miniature painted of 'Canada's Loveliest Child', Doris Elizabeth Hyde, whose photograph won the *Toronto Star*'s competition to find 'the child most representative of the loveliness of Canadian childhood'. Triumphing over 7,640 entries (the contest had 'aroused most unusual interest throughout the whole country'), Doris's image was never in fact to grace the Dolls' House: correspondence between the *Star*, the Canadian High Commissioner Mr Larkin, and Lucas himself suggests that an objection to removing the miniature from its frame of platinum, diamonds and pearls in order to place it in the folios alongside other

miniatures – instead of hanging it on a wall and thus 'giving it an importance all its own' (J.E. Atkinson of the *Star*) – may have been the fatal obstacle.

Many paintings by those still considered all-time greats are handsomely represented in the collection; such as the group of anguished children by Dame Laura Knight (1877–1970), giving a great shock as they stare forth. Not only was she the first full female Royal Academician since Mary Moser (1744–1819), but also a Dame of the British Empire. Mark Gertler (1891–1939), who in 1916 had savagely symbolised the War with his geometric *The Merry Go Round*, produced a powerful female face in pencil; while the eminent Victorian Sir Frank Dicksee (1853–1928) gave a hauntingly beautiful portrait alive with Pre-Raphaelite influence. George Clausen (1852–1944) has also stood the test of time; for the Dolls' House he painted the watery sun on a bleak winter's morning; for the nation he painted umpteen beautiful – and useful – records of rural life.

Two oddities must here be mentioned: Macdonald Gill (1884–1947; younger brother of the artist Eric Gill) presented *The Fairies' Dolls' House* – a scene of strangely elongated red-jacketed and blue cone-hatted fairies, as

if Noddy were painted by El Greco, building a thatched house and being watched over by a giant golden bird. Golden stars shine in a bright blue sky. Gill, an architect, muralist, illustrator, typographer and designer, was also responsible for the standard lettering on all First World War gravestones. Another curious addition to the Library is *The Dance of the Three Lotus Lilies* by the South African painter Winifred Brunton (1880–1959), which shows an Egyptian girl against a turquoise background, her modesty saved by three royal-blue lotus lilies. Brunton, wife of a British Egyptologist in Cairo, was famed for her somewhat creative paintings of the 'Great Ones' of Ancient Egypt.

There are so many more artists to delight in. For example, the cartoon *The Growth of Woman* by popular humorist H.M. Bateman (1887–1970) depicts two tiny men in suits, one with a bowler hat and the other a trilby,

ABOVE LEFT: Laura Knight's anguished-looking children.

ABOVE RIGHT: Lucy Macdonald's *Big Ben*, painted in evening tones of red, pink and yellow and looming large over the shining Thames, is an example of one of the paintings on lambskin.

Macdonald Gill.

H.M. Bateman.

CÆLO·TENTABIMVS·IRE

R.R.Tomlinson, A.R.C.A.

ABOVE: Macdonald Gill's *The Fairies' Dolls' House.*

ABOVE RIGHT: H.M Bateman's *The Growth of Woman.*

RIGHT: R.R. Tomlinson's *Caelo Tentabimus Ire.*

staring upwards at a skyscraper of a woman, dressed *à la mode* for the 1920s.

The last word though must go to R.R. Tomlinson – a pioneer art educator in his day – with his *Caelo Tentabimus Ire* (the title is from Ovid's *Ars Amatoria* and translates as 'We'll try the sky'). It stops you dead in your tracks. In sweeping brushstrokes, it is an update of the story of Daedalus and Icarus from Ovid's *Metamorphoses*, in which Icarus's wings, made by his father, melted as he flew too near to the sun. Here Icarus, with multi-coloured wings, stands before a pink and blue sky on a cliff by the water's edge, with mauve mountains beyond. Then, suddenly, you spot it: a bi-plane flying on high. What sensational discoveries, one and all.

The work of 25 composers is represented in the Library. Sir Edward Elgar refused, 'in a crescendo climax of rudeness' according to Siegfried Sassoon in his diaries, with Elgar fulminating in rage at the idea:

We all know that the King and Queen are incapable of appreciating anything artistic; they have never asked for the full score of my Second Symphony to be added to the Library at Windsor. But as the crown of my career I'm asked to contribute to – a Dolls'

House for the Queen! I've been a monkey on a stick for you people long enough. Now I am getting off that stick. I wrote and said I hoped they wouldn't have the impertinence to press the matter any further. I consider it as an insult for an artist to be asked to mix himself up in such nonsense.

Gustav Holst (1874–1934) thought otherwise, as did Frederick Delius, Arthur Bliss, John Ireland and Arnold Bax, amongst many more. There are 25 scores, little over an inch square, bound in leather with the Queen's monogram and all of them signed, with the exception of a posthumous 'Gigue' by Sir Hubert Parry (1848–1918). He, of course, had written the music for *Jerusalem* in 1916. Two women composers also contributed to the Library: the newly knighted Dame Ethel Smyth (1858–1944) was one.

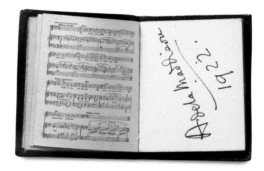

Miniature music scores by Gustav Holst, and Adela Maddison, organiser of the Dolls' House music library.

That the work of so many of the forgotten ones – as well of course of the dazzling immortals – may be discovered within these walls is one of the most potent aspects of the Dolls' House.

What a treasure it is. Never has a generation been so meticulously memorialised: from Bromo lavatory paper to murals by William Nicholson and Edmund Dulac; from pre-penicillin pneumonia vests to handwritten books by Kipling and Conan Doyle. With such sights amidst the wealth of contemporary decoration, art and architecture, literature and music, all enlivened by enchanting contributions from industrialists and manufacturers, the spirit of an age has been forever captured within these little walls. It is nothing short of magical, a word that when describing Queen Mary's Dolls' House can never be used enough.

It has been built to outlast us all, to carry on into the future and different world this pattern of our own. It is a serious attempt to express our age and to show forth in dwarf proportions the limbs of our present world.

A.C. Benson
The Book of The Queen's Dolls' House, 1924

List of Makers, as set out in
The Book of The Queen's Dolls' House

Category	Object	Name of firm
Balustrade		J. Starkie Gardner
Barometer		Cartier Ltd
Bathroom Accessories	Soap	J. & E. Atkinson Ltd
Bathroom Accessories	Soap	Lever Bros. Ltd
Bathroom Accessories	Soap	A. & F. Pears Ltd
Bathroom Accessories	Toilet Requisites	The Diamond Mills Paper Co.
Bathroom Accessories	Toilet Requisites	J. C. Eno Ltd
Bathroom Accessories	Toilet Requisites	Noble & Co.
Bathroom Accessories	Toilet Requisites	The Twining Models Ltd
Bathroom Accessories	Toilet Requisites	Allen & Hanburys Ltd
Bathroom Accessories	Toilet Requisites	Boots Cash Chemists Ltd
Beds		Gill & Reigate Ltd
Beds		Lines Brothers Ltd
Beds		Muntzer & Son
Beds		Peyton Hoyland & Barber Ltd
Beds		P. Waals
Bicycles		Rotherham and Sons Ltd
Bicycles		Rudge-Whitworth Ltd
Biscuits	Biscuit labels	Jenner and Co.
Biscuits	Biscuit tins	Elkington & Co. Ltd
Biscuits	Biscuits	Huntley & Palmers Ltd
Biscuits	Biscuits	McVitie & Price Ltd
Bookbinding	Visitors' Book Blotting Pad	Sangorski & Sutcliffe
Bookbinding		Birdsall & Son
Bookbinding		Hatchards
Bookbinding		Mrs A. Loosely
Bookbinding		Robert Riviere & Son
Bookbinding		The Rotary Binders
Bookbinding		Zaehnsdorf Ltd
Books and Periodicals printed	*A.B.C. Railway Guide*	W. Clowes & Sons Ltd
Books and Periodicals printed	*Bradshaw's Guide*	Blacklock Henry & Co. Ltd
Books and Periodicals printed	*Country Life*	Hudson and Kearns Ltd

Category	Object	Name of firm
Books and Periodicals printed	*Daily Mail*	F. Goulding
Books and Periodicals printed	*Father Tuck's Annual*	Raphael Tuck & Sons Ltd
Books and Periodicals printed	*Field*	Hudson and Kearns Ltd
Books and Periodicals printed	*Morning Post*	Reproduced by John Swain and Son Ltd
Books and Periodicals printed	*Pearson's Magazine*	Reproduction by The Century Engraving Co.
Books and Periodicals printed	*Punch*	Bradbury Agnew & Co. Ltd
Books and Periodicals printed	*Saturday Review*	Herbert Reiach Ltd
Books and Periodicals printed	*The Strand Magazine*	The Sun Engraving Co. Ltd
	The Times	
	The Times of India	
Books and Periodicals printed	*Truth*	J. Whitaker & Sons Ltd /
		Printed by W. Clowes and Sons Ltd
Books and Periodicals printed	*Whitaker's Almanack*	J. Whitaker & Sons Ltd /
		Printed by W. Clowes and Sons Ltd
Books and Periodicals printed	*Who's Who*	A. & C. Black Ltd
Broom		The Birmingham Royal Institution for the Blind
Calendars		Raphael Tuck & Sons Ltd
Calendars		W.H. Smith & Son (The Arden Press)
Candles		Price's Patent Candle Co. Ltd
Carpets and Rugs		Madame Hayward
Carpet and Rugs		W. Roberson-Taylor
Carpets and Rugs		Mrs Rowland Alston
Carpets and Rugs		The Gainsborough Silk Weaving Co. Ltd
Carpets and Rugs		Luther Hooper
Carpets and Rugs		Miss Margaret Kinnell
Carpets and Rugs		Muntzer & Son
Carpets and Rugs		Ernest Thesiger
Carpets and Rugs		Weaving School for Crippled Girls
Chandeliers		Crichton Bros.
Chandeliers		Elkington & Co. Ltd
Chandeliers		Noble & Co.
Chandeliers		Mrs Graydon Stannus

Category	Object	Name of firm
Cheque Book		Lloyds Bank Ltd / Printed by W.W. Sprague and Co. Ltd
Chess		J. Jaques & Son Ltd
China	Porcelain	The Cauldon Potteries Ltd
China	Porcelain	The Worcester Royal Porcelain Co. Ltd
China		Doulton & Co. Ltd
China		Thomas Goode & Co. Ltd
China		Mintons Ltd
China		A.R. Payne
China		Stafford Workshops for the Blind
China		Josiah Wedgwood & Sons Ltd
Cleaning Utensils	Kitchen cloths	The Old Bleach Linen Co. Ltd
Cleaning Utensils	Ladder, Dustpan and Brush, Pail and Brooms	The Twining Models Ltd
Cleaning Utensils	O-Cedar Mop	Channell Chemical Co. of England Ltd
Cleaning Utensils	Sweeper	Hoover Suction Sweeper Co. Ltd
Clocks		Cartier Ltd
Decoration	Ceiling	William Walcot R.B.A.
Decoration	Hall Ceiling	Winifred Guinness
Decoration	Ivory Ceiling	G. Garbe & Sons
Decoration	Interior and Exterior Paintwork	Muntzer & Son
Decoration	Rubber Flooring	The North British Rubber Co. Ltd
Decoration	Sculpture	Mr V. Martorell
Decoration	Silk Hangings	Muntzer & Son
Decoration	Silk Hangings	The Gainsborough Silk Weaving Co. Ltd
Decoration	Silk Hangings	Warner & Sons
Decoration	Slates for Roof	Stirling & Johnson Ltd
Decoration	Upholstery	Howard & Sons Ltd
Decoration	Upholstery	Muntzer & Son
Decoration	Woodcarving	Broadbent Eric
Decoration	Woodcarving	W. Turner Lord & Co.
Decoration		Oscar Callow
Decoration		Martin Van Straaten & Co.

Category	Object	Name of firm
Dolls	Dolls	Mr & Mrs Kennedy North
Dolls	Dolls' Boots	Peal and Co.
Dolls	Dolls' Coats and Trousers	Simpson and Sons
Dolls	Dolls' Waterproofs	H. E. Mills Ltd
Electrics	Electric Light Bells etc	Higgins & Griffiths Ltd
Fire Accessories	Fire Extinguisher	Minimax Ltd
Fire Accessories	Fire Grates, Ranges etc	Godfrey Crittall
Fire Accessories	Fire Grates, Ranges, Irons etc.	Thomas Elsley Ltd
Fire Accessories	Fire Irons	Frederick Partridge
Fire Accessories	Fire Lighters	Certo Ltd
Flags		Lt.-Com Chappell
Flags		Cecil King
Flags		Mrs Terese Mehan
Flowers		Fabergé
Flowers		Miss B. Hindley
Flowers		F. Morrell
Flowers		Mrs. Avery Robinson
Foodstuffs	Cocoa, Chocolate etc.	Carson's Ltd
Foodstuffs	Cocoa, Chocolate etc.	J. S. Fry & Sons
Foodstuffs	Cocoa, Chocolate etc.	Rowntree & Co. Ltd
Foodstuffs	Cocoa, Chocolate etc., Labels	E.S. and A. Robinson Ltd
Foodstuffs	Cocoa, Chocolate etc., Tins	Bristol Goldsmiths' Alliance
Foodstuffs	Jams and Marmalade	Chivers & Sons Ltd
Foodstuffs	Jams and Marmalade Jars	The United Glass Bottle Manufacturers Ltd
Foodstuffs	Jams and Marmalade Labels	Enderby and Co. Ltd
Foodstuffs	Jams Parchment Covers Labels and Jars	Wilkin & Sons Ltd
Foodstuffs	Marmalade	Frank Cooper Ltd
Foodstuffs	Marmalade Jars	C.T. Maling and Sons
Foodstuffs	Marmalade Labels	Thomas de la Rue and Co. Ltd
Foodstuffs	Nursery Chocolates	Rowntree & Co. Ltd
Foodstuffs	Nursery Food	Allen & Hanburys Ltd
Foodstuffs	Nursery Food etc	Glaxo (J. Nathan & Co. Ltd)

Category	Object	Name of firm
Foodstuffs	Nursery Sweets and Crackers	J. Pascall Ltd
Foodstuffs	Swiss Milk	Nestlé and Anglo-Swiss Condensed Milk Co.
Foodstuffs	Swiss Milk Tins	Searle and Co. Ltd
Foodstuffs	Tea and Coffee	R. Twining & Co. Ltd / J. Hatfield and Sons Ltd
Foodstuffs	Tea, Coffee, Cocoa, Jelly, Cream Chocolates, One Tin 'Milkal'	Joseph Lyons & Co. Ltd
Foodstuffs	Vinegar	R. Jackson & Co. Ltd
Foodstuffs	Worcester Sauce	Lea & Perrins
Foodstuffs	Worcester Sauce Bottle	Bagley and Co.
Foodstuffs	Worcester Sauce Red Label	Thomas de la Rue and Co. Ltd
Foodstuffs	Worcester Sauce White Label	Philips and Probert
Furniture	Card Table	The League of Remembrance
Furniture	Cradle	Amédée Joubert & Son
Furniture		J. Batson & Sons
Furniture		T. Collins
Furniture		Edwards & Sons
Furniture		Gill & Reigate Ltd
Furniture		J. Herrmann
Furniture		Howard & Sons Ltd
Furniture		R. Langhorn & Field
Furniture		Harris Lebus
Furniture		Lines Brothers Ltd
Furniture		P. Metge
Furniture		Nicholls & Janes
Furniture		J. Parnell & Son
Furniture		Barton Prior
Furniture		J. Rowcliffe
Furniture		William H. Saunders
Furniture		Scullard & Bartle
Furniture		R. A. Seraphin
Furniture		W. Turner Lord & Co.
Garage	Vauxhall Clock, Pedometer, Petrol	S. Smith and Sons Ltd

Category	Object	Name of firm
	Level Indicator	
Garage	Daimler Limousine	The Daimler Co. Ltd
Garage	Daimler Limousine Coachwork	Barker and Co. Ltd
Garage	Daimler Station Bus	The Daimler Co. Ltd with The Twining Models Ltd
Garage	Fire Engine	W. Bailey
Garage	Lanchester	The Lanchester Motor Co. Ltd
Garage	Lanchester Tyres	Dunlop Rubber Co. Ltd
Garage	Lanchester Wheels	Rudge-Whitworth Wheel Co.
Garage	Motorcycle with Side-car	Rudge-Whitworth Ltd
Garage	Rolls-Royce	Rolls-Royce Ltd
Garage	Rolls-Royce Chassis, Coachwork etc	The Twining Models Ltd
Garage	Rolls-Royce Paintwork	Hooper and Co. Ltd
Garage	Rolls-Royce Tyres	Dunlop Rubber Co. Ltd
Garage	Sunbeam	Sunbeam Motor Car Co. Ltd
Garage	Vauxhall	Vauxhall Motors Ltd
Garage	Vauxhall Carburetter	Zenith Carburetter Co. Ltd
Garage	Vauxhall Lighting Set with Bulbs, Dynamo, Self-Starter and Switchboard	C.A. Vandervell and Co. Ltd
Garage	Vauxhall Magneto	North and Sons Ltd
Garage	Vauxhall Radiator Badge	W.O. Lewis (Badges) Ltd
Garage	Vauxhall Tyres	Dunlop Rubber Co. Ltd
Garden	Accessories	Abol Ltd
Garden	Accessories	Thomas Elsley Ltd
Garden	Accessories	A.W. Gamage Ltd
Garden	Accessories	H.T. Jenkins & Son Ltd
Garden	Accessories	Moseley & Co. Ltd
Garden	Accessories	Edwards Patterson
Garden	Accessories	C.H. Pugh Ltd
Garden	Accessories	Mrs G.F. Watts
Garden	Accessories	The Whiteside Fitments Co.
Garden	Arrangement	Miss Gertrude Jekyll
Garden		Miss B. Hindley

Category	Object	Name of firm
Glass	Glass Case	Webb's Crystal Glass Co. Ltd
Glass		Delta Metal Co. Ltd
Glass		Doulton & Co. Ltd
Glass		Thomas Goode & Co. Ltd
Glass		James Powell & Sons (Whitefriars) Ltd
Glass		Mrs Graydon Stannus
Glass		The Crittall Manufacturing Co. Ltd
Glass		The United Glass Bottle Manufacturers Ltd
Jewels and Regalia		H.G. Murphy
Jewels and Regalia		Mrs Sintzenich
Jewels and Regalia		Cecil Thomas
Jewels and Regalia		Miss W. M. Whiteside A.R.M.S.
Kitchenware	Jars and Jugs	Doulton & Co. Ltd
Kitchenware	Knife Machine	George Kent Ltd
Kitchenware	Pots and Pans	Guy's Hospital
Kitchenware	Rolling-pin, Scrubbing Brushes etc.	The Twining Models Ltd
Kitchenware	Saucepans, Kettles etc.	Richard Crittall & Co. Ltd
Kitchenware	Saucepans, Kettles etc.	Lee & Wilkes Ltd
Kitchenware	Saucepans, Kettles etc.	Capt. H. Lyon Thomson
Kitchenware	Scissors	Joseph Rodgers & Sons Ltd
Kitchenware	Selvyt Cloths	W.P. Jones & Co.
Kitchenware	Weighing Machines	Allen & Hanburys Ltd
Kitchenware	Weighing Machines	George Salter & Co. Ltd
Lamps		Faraday & Son Ltd
Lamps	Lanterns	J. Starkie Gardner
Leatherwork		Sangorski & Sutcliffe
Linen	Cotton	J. & P. Coats Ltd
Linen	Sewing Machine	Singer Sewing Machine Co. Ltd
Linen		The Old Bleach Linen Co. Ltd
Locks, Handles and Bolts		Thomas Elsley Ltd
Maps	Atlas hunting and Motor Maps	Edward Stanford Ltd
Marblework		H.T. Jenkins & Son Ltd

Category	Object	Name of firm
Metalwork	Lead Vases	Thomas Elsley Ltd
Metalwork		Bennett Bros.
Metalwork		H.J. Hatfield & Sons Ltd
Metalwork		Noble & Co.
Metalwork		Percy Webster
Miscellaneous	Glaxo Baby Book	Glaxo
Miscellaneous	Globes	The Twining Models Ltd
Miscellaneous	Gramophone	The Gramophone Co. Ltd
Miscellaneous	Hot-water Cans	J. Batson & Sons
Miscellaneous	Insurance Policy (in safe)	Aviation and General Insurance Co. Ltd
Miscellaneous	Matches	Bryant & May Ltd
Miscellaneous	Sea Trout	Mr and Mrs J. Tully
Miscellaneous	Trunks	Davis & Co.
Miscellaneous	Umbrellas	S. Fox & Co. Ltd
Miscellaneous	Umbrellas and Sticks	Brigg & Sons
Miscellaneous	Wireless Cabinet Receiver	The British Thomson-Houston Co. Ltd
Miscellaneous		Dryad Cane Furniture
Miscellaneous		Roger North
Miscellaneous		Spink & Son Ltd
Miscellaneous		Women's Institute, Booton
Models	Model of Horse	Mr H. Haseltine
Models	Model of Royal George	The Twining Models Ltd
Music	Pianos	John Broadwood & Sons Ltd
Music		Mrs Adela Maddison / Novello & Co. Ltd
Needlework	Firescreen	Needlecraft
Needlework		Mrs Robert Benson
Needlework		Miss Dorothy Carter
Needlework		Mrs F. De Pennington
Needlework		Miss E. G. Fellows
Needlework		Miss Gregory
Needlework		Miss Clara Kettlewell
Needlework		Royal School of Needlework

Category	Object	Name of firm
Perambulators		E. T. Morris & Co. Ltd (The Marmet Baby Carriage Syndicate Ltd) with The Twining Models Ltd
Photography	Camera and Album	Kodak Ltd
Photography	Photographs	Alexander Corbett / Country Life
Photography	Photographs	E.O. Hoppé
Photography	Photographs	Vincent Brooks Day & Son Ltd
Picture Frames	Framing	Noble & Co. Ltd
Picture Frames		Thomas Elsley Ltd
Picture Frames		Amédée Joubert & Son
Plans		Vincent Brooks Day & Son Ltd
Polish	Boot Polish, Pad, Tin and Brush	Nugget Polish Co. Ltd
Polish		'Ronuk' Ltd
Polish		O-Cedar Polish
Posters	Paper	Dixon and Roe
Posters	Printing	Vincent Brooks Day & Son Ltd
Sanitary Fittings and Plumbing		John Bolding & Sons Ltd
Silverware	Cutlery	The Twining Models Ltd
Silverware		E. Barnard & Sons Ltd
Silverware		Chester Electro-Plating Co.
Silverware		Frank Finley Clarkson
Silverware		Crichton Bros.
Silverware		F.A. Edwardes
Silverware		Garrard & Co. Ltd
Silverware		Mappin & Webb Ltd
Silverware		Miss W.M. Whiteside A.R.M.S
Sporting Accessories	Archery	F.H. Ayres Ltd
Sporting Accessories	Cricket Set, Stumps and Ball	John Wisden & Co. Ltd
Sporting Accessories	Croquet	F.H. Ayres Ltd
Sporting Accessories	Fencing Foils, Mask and Glove	Amédée Joubert & Son
Sporting Accessories	Fishing Tackle	Hardy Bros. Ltd
Sporting Accessories	Golf	F.H. Ayres Ltd
Sporting Accessories	Golf Bag (leather)	J.T. Goudie & Co.

Category	Object	Name of firm
Sporting Accessories	Driver and Brassie	C. Gibson, Westward Ho
Sporting Accessories	Putter, Cleek Iron, Benny	Ben Sayers / N. Berwick
Sporting Accessories	Gun Cartridges	Nobel's Explosive Co. Ltd
Sporting Accessories	Guns	James Purdey & Sons
Sporting Accessories	Shooting Stick	Brigg & Sons / J. Purdey & Sons
Sporting Accessories	Tennis Rackets and Presses	F.H. Ayres Ltd
Stationery	Ink	Henry C. Stephens
Stationery	Inkstand	Crichton Bros.
Stationery	Pencils	George Rowney & Co.
Stationery	Pens, Fountain and Quill	Mabie Todd & Co. Ltd
Stationery	Pens, Fountain, Quill, Ivory Paper-knife and Pen-wiper	Lady Gertrude Crawford
Stationery	Stationery Boxes, Waste-paper baskets etc.	W. Busson & Son Ltd
Stationery	Stationery Boxes, Waste-paper baskets etc.	Sangorski & Sutcliffe
Stationery		Waterlow & Sons Ltd
Strong Room	Jewel Safe	Chubb & Son's Lock and Safe Co. Ltd
Strong Room	Safe and Strong Room	The Chatwood Safe Co. Ltd
Structure	Lifting Apparatus	Redpath Brown & Co. Ltd
Structure	Lifts	Waygood Otis Ltd
Structure	Steps	Steps & Tables Ltd
Structure		J. Rugby Parnell & Son
Tobacco, Cigars, Cigarettes, Pipes		Dexter Bros
Tobacco, Cigars, Cigarettes, Pipes		A. Dunhill Ltd
Tobacco, Cigars, Cigarettes, Pipes		Walters & Co ('Bolivar')
Toys, including Dolls' Rifles and Train		Bassett-Lowke Ltd
Toys		Pomona Toys
Toys		J. Batson & Sons
Toys		Britains Ltd
Toys		V. Hembrow
Toys		Mappin & Webb Ltd
Toys		Kennedy North
Toys		W.G. Simmonds

Category	Object	Name of firm
Toys		Norman Wilkinson
Toys		Windsor & Newton Ltd
Weaponry	Armour	Paul Hardy
Weaponry	Swords	Wilkinson Sword Co. Ltd
Wine Cellar	Bottles	J. Powell & Sons (Whitefriars) Ltd
Wine Cellar	Bottles	The United Glass Bottle Manufacturers Ltd
Wine Cellar	Bottles and Cases	Webb's Crystal Glass Co. Ltd
Wine Cellar	Cellar Book	Sangorski & Sutcliffe
Wine Cellar	Champagne Cases	L. Olry Roederer, Reims
Wine Cellar	Labels	McCorquodale and Co. Ltd
Wine Cellar	Labels	Thomas de la Rue and Co. Ltd
Wine Cellar	Straw Envelopes	Mrs Francis L. Berry
Wine Cellar	Basket	A. Brown
Wine Cellar	Bins, Labels etc	J. Batson and Sons Ltd
Wine Cellar	Wine, Spirits etc	Bass Ratcliff & Gretton Ltd
Wine Cellar	Wine, Spirits etc	Doulton & Co. Ltd
Wine Cellar	Wine, Spirits etc	W. & A. Gilbey Ltd
Wine Cellar	Wine, Spirits etc	Tanqueray, Gordon & Co. Ltd
Wine Cellar	Wine, Spirits etc	John Walker & Sons Ltd

Catalogue of The Dolls' House Library

MANUSCRIPTS

King's Bedroom

E.V. Lucas, *The Whole Duty of Dolls*

Library

Autograph book of the Navy

Autograph book of the stage

Autograph book of statesmen

F. Anstey, *The Wisdom of Piljosh*

H.H. Asquith, *Culture and Character*

F.W. Bain, *Leaves of the Lotus*

C.H. Collins Baker, *Art Seen Through Doll Eyes*

Maurice Baring, *Elegy on the Death of Juliet's Owl*

J.M. Barrie, *Autobiography of J.M. Barrie*

Sir Max Beerbohm, *Meditations of a Refugee*

Harold Begbie, *The Untruth That Came True*

Hilaire Belloc, *Peter and Paul: A Moral Tale*

Arnold Bennett, *Christmas Eve and New Year's Eve*

Arthur Christopher Benson, *The Limpet and the Sandpiper*

E.F. Benson, *Poems*

J.D. Beresford, *Beautiful Margaret*

Francis Berry, *Stock of Wines and Spirits in the Cellars of the Royal Dolls' House at Windsor Castle*

Laurence Binyon, *Poems*

George A. Birmingham, [James Owen Hannay] *The Curragh: from 'Inisheeny'*

Algernon Blackwood, *The Vision of the wind: from 'The Education of Uncle Paul'*

Sir John Bland-Sutton, *Principles of Doll-Surgery*

Sir Reginald Theodore Blomfield, *The House of the Marquis of Carabas*

Edmund Blunden, *Poems*

Marjorie Bowen, *The Emeralds* and *A Little Chronicle*

May Bradford, *Tales from 'A Hospital Letter-writer in France'*

Robert Bridges, *Poems*

Victor Bridges, *A Merry Xmas*

Oscar Browning, *Edelweiss*

John Buchan, *The Battle of the Somme*

George Earle Buckle, *Life of Disraeli: Volumes III, IV, V & VI*

Gilbert Cannan, *The Story of a Doll*

G.K. Chesterton, *The Ballad of Three Horns*

Mary Cholmondeley, *Red Pottage*

Ethel Clifford [Dilke], *Poems from 'Songs of Dreams, 1903' & 'Love's Journey, 1908'*

Lucy Clifford, *Love-letters of a Worldly Woman*

Thomas Cobb, *An Act of Charity*

Sidney Colvin, *R.L.S. in a Nutshell*

Sidney Colvin, *The Song of Titania*

Joseph Conrad, *The Nursery of the Craft*

Julian Stafford Corbett, *Slumber Songs*

Clemence Dane, *Some Songs and Sayings from 'Will Shakespeare'*

Norman Davey, *Poems for the Young in Heart*

W.H. Davies, *Thunderstorms*

E.M. Delafield, *Anti-climax*

Walter de la Mare, *A Little Book*

Ethel M. Dell, *From 'The Bars of Iron'*

Arthur Conan Doyle, *How Watson Learned the Trick*

John Drinkwater, *Poems*

Alice Dudeney, *The Feather Bed*

Dum-Dum [John Kaye Kendall], *Dolls' Songs for a Doll's House*

Lord Dunsany, *Selections from 'The Chronicles of Rodriguez'*

Oliver Elton, [Untitled]

Viscount Reginald Baliol Brett Esher, *Maxims*

Jeffery Farnol, *The Broad Highway: A Romance of Kent*

Frederick Fetherstonhaugh, *The Sandringham Stud Book*

Fougasse [Cyril Kenneth Bird], *J. Smith*

Gilbert Frankau, *Peter Jackson: Cigar Merchant*

James George Frazer, *The Reading of the Bible*

John Galsworthy, *Memories*

Charles Garvase, *History of Windsor Castle*

W.L. George, *History of Woman*

Philip Gibbs, *The Unknown Warrior*

Oliver St John Gogarty, *Apples of Gold*

Edmund Gosse, *A French Doll's House*

Harry Graham, *Ruthless Rhymes for Heartless Homes*

Stephen Graham, *How the Old Pilgrim Reached Bethlehem*

Winifred Graham, *Royal Lovers*

Charles L. Graves, *Norfolk*

Robert Graves, *Poems: Abridged for Dolls and Princes*

Pamela Grey, *Star Dust: A Little Poetry Book for Her Majesty's Dolls' House*

H. Rider Haggard, *From 'A Farmer's Year'*

Viscount R.B. Haldane, *An Essay on Humanism*

Thomas Hardy, *Poems*

Beatrice Harraden, *Failure and Success*

Frederic Harrison, *John Ruskin*

Ian Hay, *A Very Short Story*

Graily Hewitt, *The Prettiest Doll, by Charles Kingsley*

Maurice Hewlett, *Poems on Several Occasions*

Robert Hichens, *The Garden of Allah*

Ralph Hodgson, *Eve and Other Poems*

Anthony Hope, *A Tragedy in Outline*

A.E. Housman, *Poems*

A.S.M. Hutchinson, *From 'If Winter Comes'*

Horace G. Hutchinson, *A Manual of Games*

Aldous Huxley, *Poems*

W.W. Jacobs, *From 'Salthaven'*

M.R. James, *The Haunted Dolls' House*

Agnes Jekyll, *The Doll's-House Cookery-Book*

Gertrude Jekyll, *The Garden*

F. Tennyson Jesse *My Town*

Harry Johnston, *Jeannette Sidebotham*

Henry Arthur Jones, *English Dukes and American Millionaires*

Rudyard Kipling, *Verses*

Edward Knoblock, *The Doll's Dilemma: A Comic Tragedy*

Ronald Arbuthnott Knox, *More Memories of the Future: Being Memoirs of the Years 1915–1972 by Opal, Lady Porstock*

Doris M. Lee, *Songs of Innocence, by William Blake*

Katherine Lloyd, *Birthday Book*

William John Locke, *Miles Ignotus: A Little Tale of the Great War*

Marie Belloc Lowndes, *Why They Married and Why They Remained Married*

St John Lucas, [Poem]

Sir Henry W. Lucy, *Diary of a Journalist*

Rose Macaulay, *The Alien. The Thief*

Patrick MacGill, *The Wee Red-headed Man*

Compton Mackenzie, *Richard Gunstone*

W.H. Mallock, *Verses*

Charles Marriott, *Little Things*

Sir Edward Howard Marsh, *Georgian Poetry 1911–1921*

Archibald Marshall, *The Twins & Miss Bird*

A.E.W. Mason, *The Silver Ship*

W. Somerset Maugham, *The Princess & the Nightingale*

W.B. Maxwell, *The Companions*

Stephen McKenna, *Sonia, Between Two Worlds*

Leonard Merrick, *Conrad in Quest of his Youth*

Alice Meynell, *Poems*

A.A. Milne, *Vespers*

Frank Frankfort Moore, *The Way to Keep Him*

Elinor Mordaunt, *The Garden of Contentment*

Evan Morgan, *Poems*

Frederick Muller, *The Queen's Dolls' House*

Sir Henry John Newbolt, *Poems*

Harold Nicolson, *The Detail of Biography*

W.E. Norris, *A Peasant of Lorraine*

Alfred Noyes, *The Elfin Artist*

E. Phillips Oppenheim, *The Villa D'Everon*

Barry Pain, *Maud*

Max Pemberton, *Lion Heart: A Story*

Joseph Pennell, *Thoughts*

Eden Phillpotts, *The River Dart*

Arthur Wing Pinero, *Little Fables*

Frederick Pollock, *Queen Titania's Chancellor*

Sir D'Arcy Power, *A Miniature History of Saint Bartholomew's Hospital*

Arthur ['Q'] Quiller-Couch, *Verses*

W. Pett Ridge, *Mord Em'ly*

Rita [Eliza Humphreys], *The Road to Anywhere*

Elizabeth Robins, *Come and Find Me*

A. Mary F. Robinson, *Small Songs Chosen from her Poems*

Sir E. Denison Ross, *An Outline of Dollery*

Effie Adelaide Rowlands, *About the Children from 'The Glad Heart'*

V. Sackville-West, *A Note of Explanation*

Michael Sadleir, *A Picture of Morvane*

George Saintsbury, *Some Banalities*

Siegfried Sassoon, *Everyone Sang*

Owen Seaman, *Verses*

Anne Douglas Sedgwick, *From 'The Shadow of Life'*

Shorter, Clement King, *The Brontë Children*

Una L. Silberrad, *The Little Thatched House*

May Sinclair, *From 'The Life of Arnold Bywater'*

Ethel Smyth, *The Empress Eugénie*

E.Œ. Somerville, *Some Extracts from the Writings of E.Œ. Somerville and Martin Ross*

Cornelia Sorabji, *The Flute-Player's Dolls*

Sir John Collings Squire, *An Acrostic Sonnet on the Queen's Dolls' House*

H. de Vere Stacpoole, *Star Dust, or Verses from Sappho*

James Stephens, *Poems*

G.S. Street, *The Ghosts of Albany*

Alfred Sutro, *A Maker of Men*

Frank Swinnerton, *The Boys*

E.D. Swinton, *What the Mulberry Saw, by Ole Luk-Oie*

Basil Thomson, *The Elixir*

E. Temple Thurston, *When the Day Ends*

Katharine Tynan, *Poems*

Horace Annesley Vachell, *Pepper & Salt*

Elizabeth von Arnim, *How Mr Elliott Became Engaged to Anna-Felicitas*

Charles F.A. Voysey, *Ideas in Things*

Arthur Bingham Walkley, *Histrionics for Dolls: A Letter to a Debutante*

Hugh Walpole, *The House in the Lonely Wood*

Mary C.E. Wemyss, *White's Lane*

Stanley John Weyman, *The Two Pages*

Charles Whibley, *Brummel and Dandyism*

A.M. Williamson, *Doll or Fairy?*

George Charles Williamson, *A Book of Royal Portraits*

Owen Wister, *Belinda the Bold*

Margaret L. Woods, *Poems*

Filson Young, *A Toy Philosophy*

Francis Brett Young, *Extracts from the Work ... of Francis Brett Young*

MUSIC SCORES

Library

Frederic Austin, *Margaret*

Edgar L. Bainton, *Country Dance*

Bax, Arnold, *Nereid*

Lord Gerald Hugh Tyrwhitt-Wilson Berners, *The Lady Visitor in the Pauper Ward*

Arthur Bliss, *Madam Noy*

York Bowen, *Fragments from Hans Andersen: VIII, The Hardy Tin Soldier*

Frank Bridge, *Adoration*

Frederick Bridge, *Crossing the Bar*

Frederic H. Cowen, *Childhood (Lullaby)*

Walford Davies, *Solemn Melody*

Edward German, *Pavane*

Eugene Goossens, *Dance Memories*

Hamilton Harty, *The Rachray Man*

Joseph Holbrooke, *In Days of Old*

Gustav Holst, *Four Songs for Voice and Violin*

John Ireland, *The Adoration*

Alexander Campbell Mackenzie, *Distant Chimes*

Adela Maddison, *Vierter Aufzug*

John B. McEwen, *Highland Dances III*

Walter Parratt, *The Knight's Leap*

C. Hubert H. Parry, *Gigue*

Roger Quilter, *Fairy Lullaby*

Ethel Smyth, *The Dance*

Charles Villiers Stanford, *The Broken Toy* and *The New Toy*

NEWSPAPERS AND MAGAZINES

King's Bedroom

The Times, 1 January 1924

Servant's Room 1

Country Life, 19 September 1923

Servant's Room 5

*Weldon's Ladies' Journal, c.*1924–8

Housekeeper's Room

*The Strand Magazine: Queen Mary's
 Doll's House*, 1924

Linen Room

The Morning Post, 9 October 1922

*Weldon's Ladies' Journal, c.*1924–8

Bathroom

*Weldon's Ladies' Journal, c.*1924–8

Library

The Architectural Review, June 1924

Country Life, 19 September 1923

The Morning Post, 9 October 1922

Saturday Review, 5 January 1923

The Times, 1 January 1924

The Times of India, 27 February 1924

Truth, 18 March 1923

PRINTED BOOKS

Saloon

L'Ami de la jeunesse 1819

Queen's Bedroom

Almanach auf das Jahr 1818

The English Bijou Almanac for 1837

Nursery

Annie Fortescue Harrison, *Songlets for
 Children*

Cecil J. Sharp, *Nursery Songs from the
 Appalachian Mountains*

Théophile Alexandre Steinlen, *Les Rondes
 de l'enfance*

Edric Vredenburg, *Father Tuck's Annual*

Queen's Sitting Room

The English Bijou Almanac for 1836

Princess Royal's Room

*The New Testament of our Lord and Saviour
 Jesus Christ*

Library

The Bible, various editions

The Bijou Almanack for 1845

*Le Conseiller des grâces dédié aux dames,
 année 1817*

The English Bijou Almanac for 1836

Étrennes à l'innocence

*Holiday and Health Resorts Guide: Official
 Illustrated Guide*

Life of Alfred the Great

LMS Timetable

*London Almanack for the Year of Our Lord
 1733*

Miniature History of England

The Mite

Pentateuch

Petit fabuliste

Le Petit polichinel

Qu'ran

Le Tableau de la vie: année 1821

The Shakespeare Glossary

Small Rain upon the Tender Herb

The Smallest English Dictionary in the World

Valeur et constance, année 1823

Wood's Royal Almanack for 1846

Hippolyte Buffenoir, *Jeanne d'Arc*

Robert Burns, *Poems Chiefly in the Scottish Dialect*

Robert Burns, *The Cottar's Saturday Night and other Poems*

Winston Churchill, *King George VI: The Prime Minister's Broadcast, February 7, 1952*

Calvin Coolidge, *Extracts from the Autobiography of Calvin Coolidge*

Alice Crowther, *Golden Thoughts from Great Authors*

Charles Dickens, a selection of stories and novels

The Smallest French and English Dictionary in the World

The English Bijou Almanac, issues 1836–1839

Abraham Lincoln, *Addresses of Abraham Lincoln*

William Moodie, *Old English, Scotch and Irish Songs with Music*

Hégésippe Moreau, *La Souris blanche: conte*

Caroline Sheridan Norton, *Schloss's English Bijou Almanac for 1842*

Queen Elizabeth II, *The Queen's Message: Broadcast on Coronation Day, 2 June 1953*

William Shakespeare, a selection of plays and sonnets

T.M., *Witty, Humorous and Merry Thoughts*

Voltaire, *Jeannot & Colin*

OTHER

Library

ABC Alphabetical Railway Guide

Album, 1922

Almanack for the Year of Our Lord 1923

Aviation & General's insurance policy for Queen Mary's Dolls' House, 20 December 1922

Blank book

Blotters

Bradshaw's General Railway and Steam Navigation Guide for Great Britain and Ireland

Horace, *Carmina sapphica*

Stanford's Atlas of the British Empire

Stamp albums

Visitors' book

Entrance Hall and Grand Staircase

Visitors' book

Queen's Bedroom

Blotter

Queen's Sitting Room

Blotter

Diary, 1924

ARTISTS

Portraits, paintings, wall and ceiling decoration and ornamentation

Clare Atwood

R. Anning Bell

F.M. Bennet

Olive Bigelow

Miss Boreel

Miss Bourne

S. Burchett

A.S. Cope

Miss Dawson

Edmund Dulac

George Frampton

W.G. de Glehn

Macdonald Gill

Maurice Grieffenhagen

Antony G. Grinling

Benjamin Guinness

Herbert Haseltine

Alfred Hemming

Dorothy Hutton

Laurence Irving

C.S. Jagger

Wm. Goscombe John

Gerald Festus Kelly

Lucy Kemp-Welch

Mrs Kenyon

Gertrude Knoblock

John Lavery

S.A. Lindsey

William Llewellyn

Ambrose McEvoy

Harrington Mann

V. Martorell

Gerald Moira

A.J. Munnings

William Nicholson

William Orpen

Bernard Partridge

Alfred Pearse

Glyn Philpot

R.A. Pinks

George Plank

Spenser Pryse

Patricia Ramsay

W.B.E. Ranken

Frank Reynolds

L. Raven-Hill

Rowland Rispin

T.M. Rooke

George Sacco

F.O. Salisbury

Miss Sclanders

E.H. Shepard

Louis Silas

Charles Sims

Adrian Stokes

Cecil Thomas

A. Van Anrooy

W. Walcot

F. Derwent Wood

Bibliography

Elizabeth Clark Ashby, *The Miniature Library of the Queen's Dolls' House*, London 2024

C. Hussey, *The Queen's Dolls House: The Palace of Their Majesties The King and Queen of Lilliput*, London 1924

Her Highness Princess Marie Louise, *My Memories of Six Reigns*, London 1956

J. Murray, *Edwin Lutyens by his Daughter Mary Lutyens*, London 1980

J. Pope-Hennessy, *Queen Mary 1867–1953*, London 1959

Clayre Percy Jane Ridley (ed.), *The Letters of Sir Edwin Lutyens to his Wife Lady Emily*, London 1985

J.M. Robinson, *Queen Mary's Dolls' House Official Guidebook*, London 2004, repr. 2006, 2009

M. Stewart-Wilson, *Queen Mary's Dolls' House*, London 1988, repr. 1989, 1995, 1998, 2000

John Summerson (ed.), *The Heavenly Mansions (and Other Essays on Architecture)*, London 1949, repr. 1998

Telephone No:
2252 Gerrard.

Telegraphic Address:
"Bindristic, London."

F. Sangorski &
G. Sutcliffe.
Bookbinders.

George Sutcliffe.

1-5 Poland Street,
Oxford Street,
London, W.1.

March 11th 19 22

Her Highness The Princess Marie Louise.
Ambassador's Court.
St. James's Palace.
S.W.

Madam,

In the excitement of opening the box of
Original Manuscripts I overlooked your letter or
I would have at once assured you that Mr. Lucas
was correct in expressing my desire to offer my
services in the formation of Her Majesty's min-
iature palace library. It will be a pleasurable
holiday recreation from our hum-drum work and do
not hesitate to send me all you desire to have
done though at the same time I would not wish to
deprive any of my colleagues of the joy of sharing
with me the binding of one of the most wonderful
libraries in the world. Mr. Kipling's manuscript
is really priceless.

I beg to remain, Madam,

Your Highness's Obedient Servant,

George Sutcliffe.

The firm of Sangorski &
Sutcliffe were binders
for many of the books
in the miniature library;
a commission that gave
them much pleasure, as
this letter shows.

First published in 2010. This edition revised and updated in 2024 by
Royal Collection Trust
York House, St James's Palace
London SW1A 1BQ

ISBN 978 1 909741 90 4
103864

10 9 8 7 6 5 4 3 2 1

A catalogue record for this book is available from the British Library.

Designer: Matthew Wilson
Publisher: Kate Owen
Project Manager: Anjali Bulley
Production Manager: Sarah Tucker
Colour reproduction: Alta Image, London
Printed on Claro silk 150gsm
Printed and bound in Wales by Gomer Press

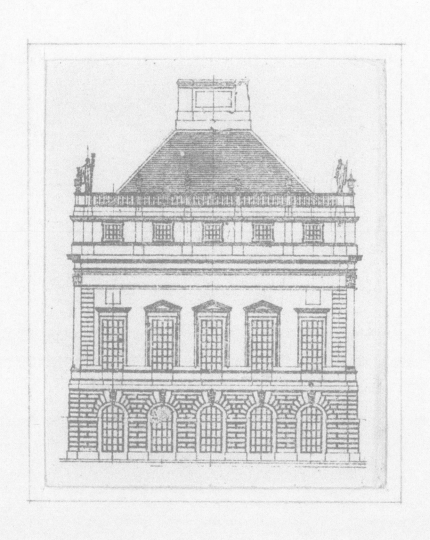